LOCHEE
THROUGH TIME
Brian King

AMBERLEY

First published 2016

Amberley Publishing
The Hill, Stroud, Gloucestershire, GL5 4EP
www.amberley-books.com

Copyright © Brian King, 2016

The right of Brian King to be identified as the
Author of this work has been asserted in accordance with
the Copyrights, Designs and Patents Act 1988.

ISBN 978 1 4456 5422 5 (print)
ISBN 978 1 4456 5423 2 (ebook)

British Library Cataloguing in Publication Data.
A catalogue record for this book is available from the
British Library.

Origination by Amberley Publishing.
Printed in Great Britain.

Introduction

Lochee today seems to be such an integral part of Dundee that it is easy to forget that its origins are as a completely separate village. Indeed, to discover the beginnings of Lochee, we must move away even from its own present-day centre and to an area that is now South Road, in the vicinity of Myrekirk, where it is thought a long-since drained loch was once situated. The earliest settlement was established at the eye or opening of the loch – the point at which it was joined by a burn. The settlement was given the name Locheye or Loche'e.

The Lochee burn attracted industry including, in the early eighteenth century, one James Cock (the spelling was later changed to 'Cox') who set up as a linen manufacturer at Locheefield. By 1793, the Cox family owned 280 handlooms. The local population grew as Lochee expanded eastwards and the area became a small village. Wander around between South Road and Liff Road today and here and there you will still see cottages that are remnants of an older Lochee nestling in narrow lanes.

In September 1816, a hare – or rather someone trying to shoot the unfortunate creature – was to change the course of Lochee's destiny. The discharge from the gun caused the thatched roof of Cox's warehouse to catch fire and led to the destruction of most of the premises. Rather than rebuild on the same site, the decision was taken to move to the Foggylea area and with that Lochee's whole centre of gravity shifted to the area around the present High Street.

In 1841, the firm of Cox Brothers was founded and, in 1850, the business moved to a new site at Harefield. At its peak, Camperdown Works employed around 5,000 people and covered more than 30 acres. The booming jute industry provided employment for local people and also attracted those who had fled poverty and hunger in Ireland in the years after the Great Famine in that country. So many Irish immigrants settled in the area around Albert Street (later known as Atholl Street) that the area was nicknamed 'Tipperary'. There are many in Lochee today who can trace their ancestry back to these immigrants.

The thirty years after the Second World War saw Lochee expand and gain suburbs of its own in the shape of various housing schemes that were employed at this time. Developments at Beechwood, Foggylea and Clement Park echoed the names of the Cox Brothers' mansions. Others such as Dryburgh, Charleston and Menzieshill took their names from the farms upon which they were built.

As Lochee was expanding outwards, redevelopment in the 1960s and 1970s had a devastating effect on its centre. Virtually all of the buildings on the western side of the main part of the High Street were demolished and Bank Street disappeared from the map entirely. Heavily populated areas such as Tipperary and Whorterbank had fallen into disrepair and were also demolished and rebuilt. Meanwhile, the Lochee bypass cut through the historic street pattern, severing the connections between the High Street and the older areas of the village.

The replacement High Street buildings had two main retail elements – the Highgate and the Weavers' Village. While the Highgate had a measure of success, the other centre was never fully occupied (or indeed known locally by the name it had been designated) and both centres have since been demolished.

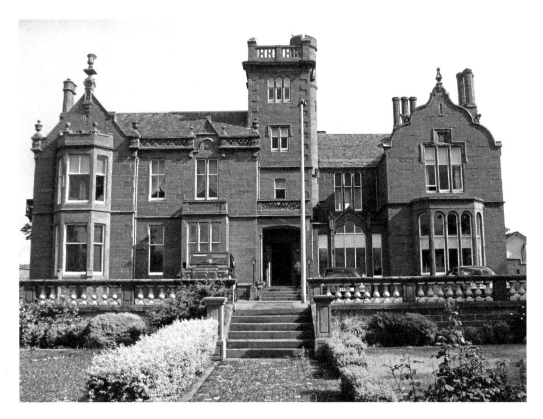

Clement Park House, one of the Cox family mansions now converted into flats.

In more recent years, the High Street has suffered from the same problems as retail areas elsewhere – in the shape of online shopping and out-of-town supermarkets. Indeed, while Lochee's earliest supermarkets, such as William Low's or Lipton's, served to draw people into the High Street, their modern equivalents, it can be argued, draw people away from it.

Recent years, however, have seen an ambitious and ongoing regeneration scheme adopted for the area. As well as more parking and housing, shopfronts have been transformed, public spaces have been opened up, Lochee Swim and Sports Centre has undergone a £1 million upgrade and even Bank Street has made a reappearance.

It was as long ago as 1859 that Lochee officially became part of Dundee. Despite this, and the many changes that have taken place over the years, the area still retains many of the characteristics of a small town, including its own distinct identity and character and the fierce loyalty of its inhabitants.

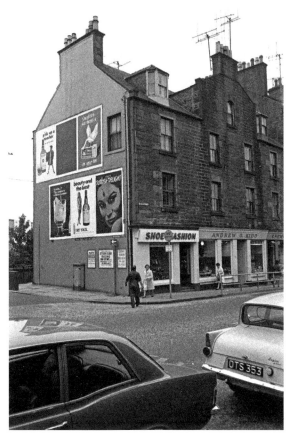

High Street at Marshall Street
Seen here in 1968, the corner building at the junction of Marshall Street and the High Street, with its advertising hoardings, was once a local landmark. The Lochee Health Centre now occupies the site.

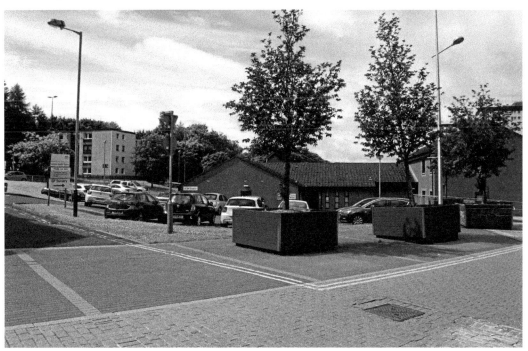

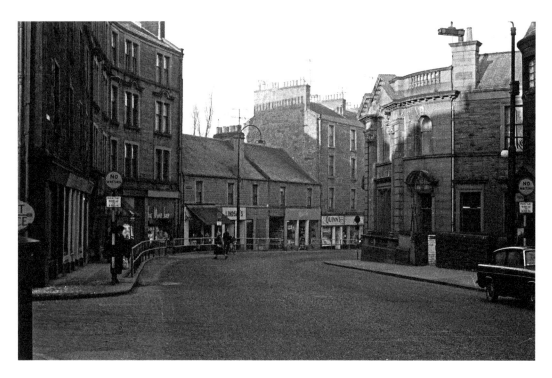

Dundee Savings Bank

The Dundee Savings Bank building (now the TSB) has remained while all the buildings on the left-hand side of the earlier view were demolished in the early 1970s. They were replaced by the houses of Doyle Place and Aimer Square (*see inset*), which have themselves since been demolished.

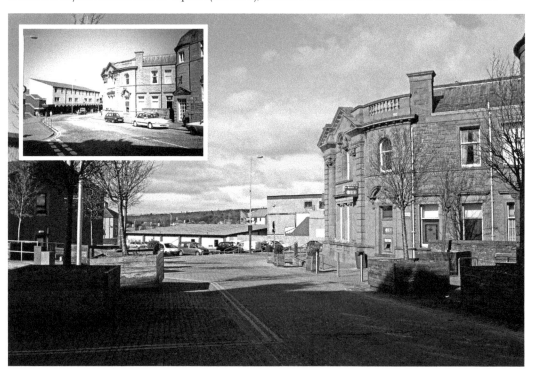

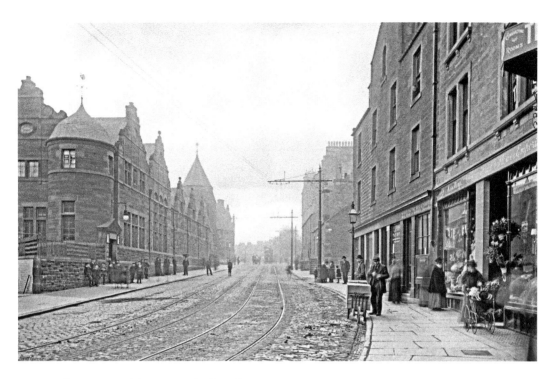

High Street Looking Towards the Library

Among the vanished buildings visible on the right of this late nineteenth-century view are the post office at No. 62 High Street and the registrar of births, deaths and marriages next door. Lochee's postmaster for more than fifty years, John Robertson, also became the local registrar when the previous incumbent, David Neish, died in the Tay Bridge disaster of 1879. The left-hand side of the street, by way of contrast, has altered little in more than a century.

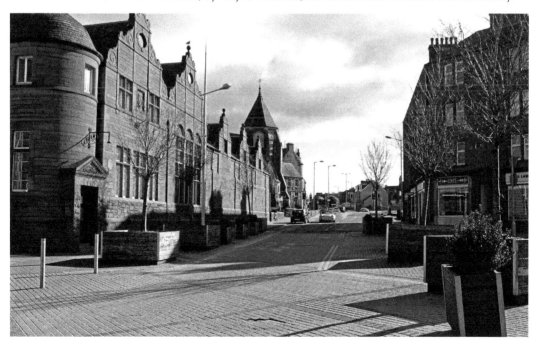

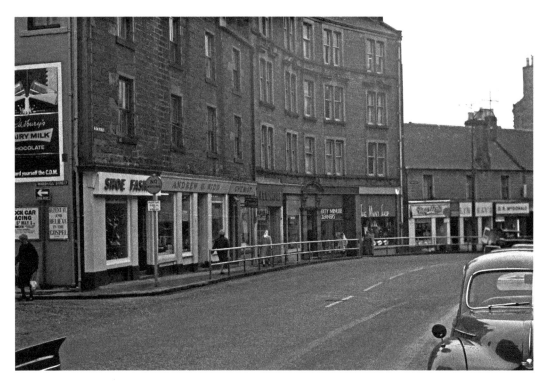

High Street Beyond Marshall Street

Less than fifty years separates these two views but the scene has been rendered unrecognisable in that time. The houses at St Ann Street are now visible from the High Street and a new street, named St Ann Lane, links the High Street to Balgay Street.

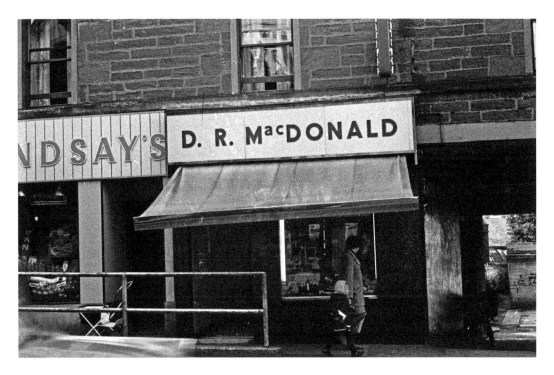

D. R. MacDonald

The older photograph shows the premises of one of Lochee's long-established family businesses – D. R. (David Robb) MacDonald's butcher's shop at No. 80 High Street. Following the demolition of this part of the High Street, the business (now D. R. MacDonald & Son) moved to No. 174 High Street, where it has been ever since.

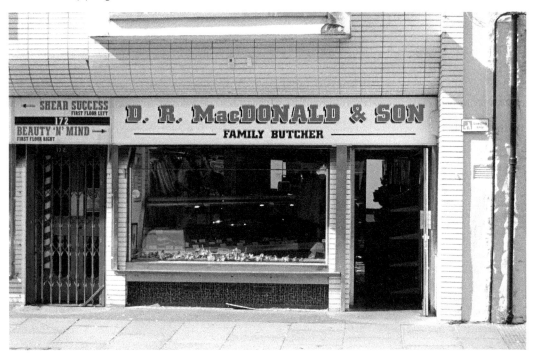

The Pend, High Street

This rare view from the other side of
the pend on Lochee High Street gives
a glimpse of a lost world, with its old
Anderson shelter converted into a shed
and a message boy's bike leaning against
the wall. Just visible through the pend
is Bellman's scotch wool shop, which is
now the Posh Nosh café.

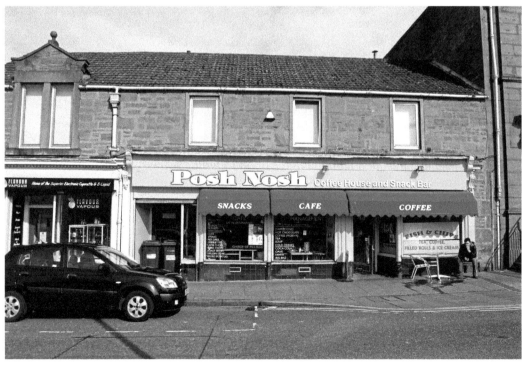

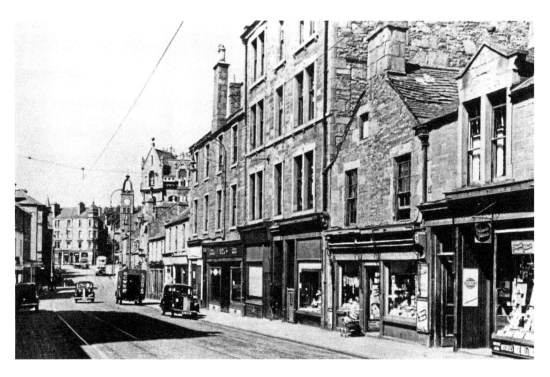

Nos 63–65 High Street

Unlike some parts, this section of the High Street has remained largely unchanged over the years. One notable difference though is that the pitched roof above the newsagent's shop has been removed – presumably for safety reasons, given its dilapidated appearance in the archive image.

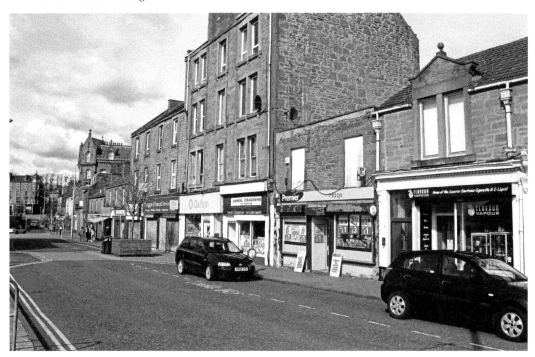

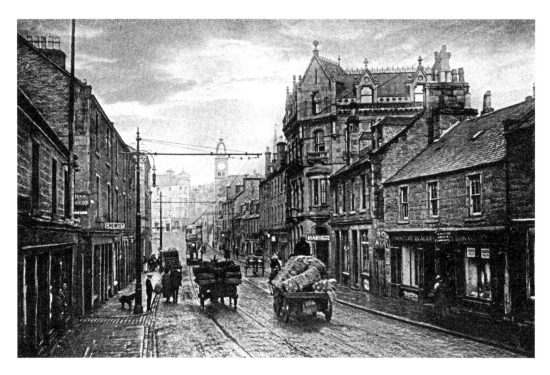

High Street at Flight's Lane

Once again, it is the right-hand side of this early twentieth-century view of the High Street that remains instantly recognisable more than a century later while not a building remains standing on the left. One thing visible on that side is the opening of Flight's Lane (*see next page*).

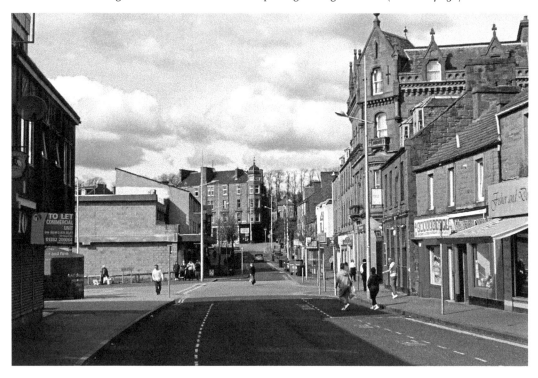

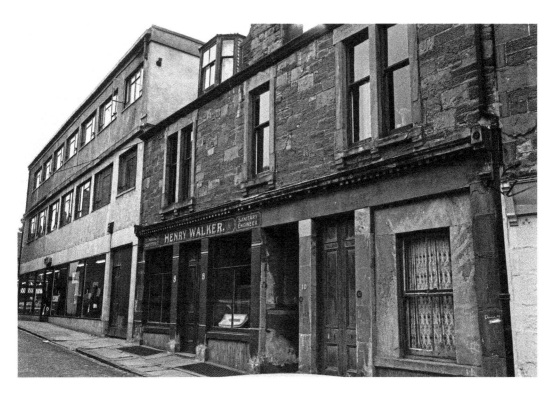

Flight's Lane

Originally a narrow lane that linked the High Street with Balgay Street, Flight's Lane, as it once existed, may have disappeared from the map but the line of its southern boundary is still visible today. It defines the new public space beside Bank Street, as a comparison of these photographs demonstrates.

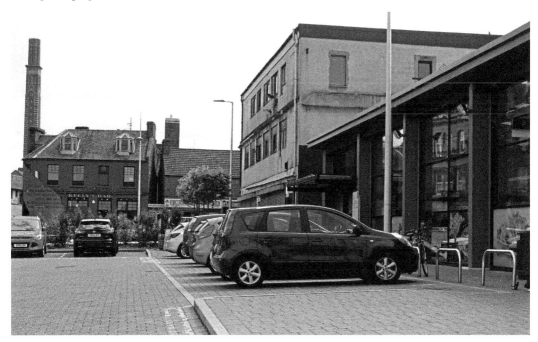

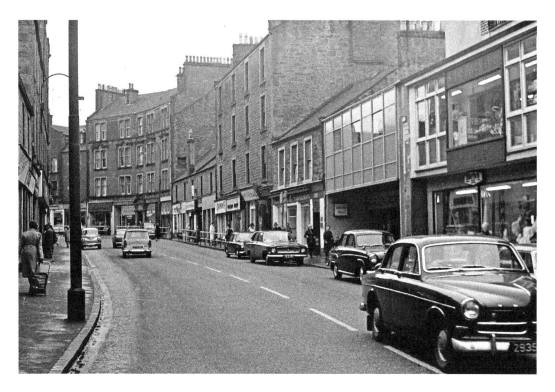

High Street from Burnside Street

A look back towards the buildings on the bend of the High Street. Everything beyond the Silvertassie pub (later the Sporting Lounge/Olympic Suite) was demolished and later replaced by a shopping centre given the picturesque name of the Weaver's Village. This was not a success however, and together with the housing above was later demolished.

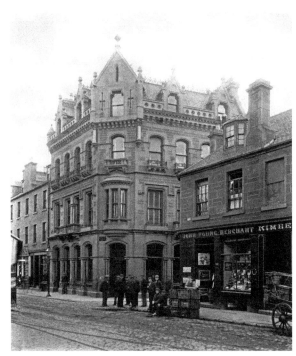

**North of Scotland Bank,
No. 93 High Street**
This landmark Lochee building dates
from 1875 and was home to the local
branch of the North of Scotland
(later Clydesdale) Bank for over a
century. While the building remains
unchanged at first sight, a closer look
reveals that the ground floor has lost
its original decorative façade.

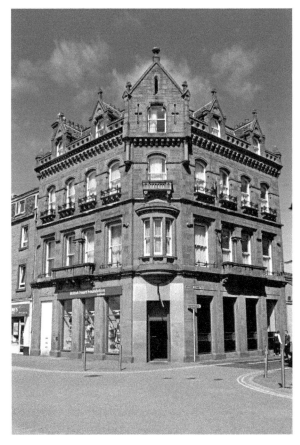

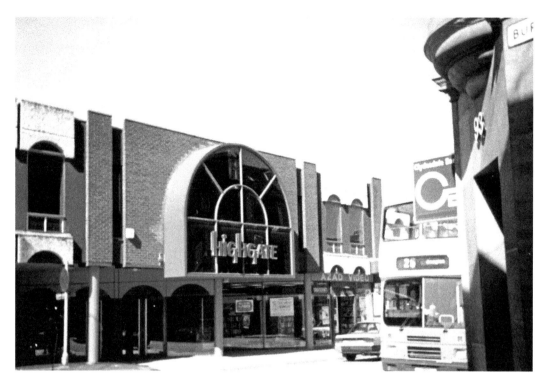

Highgate

The view from Burnside Street across the High Street has changed dramatically in recent years following the demolition of the Highgate Centre. As well as containing individual shops, it also provided access to the Fine Fare supermarket (later Food Giant). This had the beneficial effect of linking a large retail store to the High Street as opposed to the out-of-town nature of more recent developments in the area.

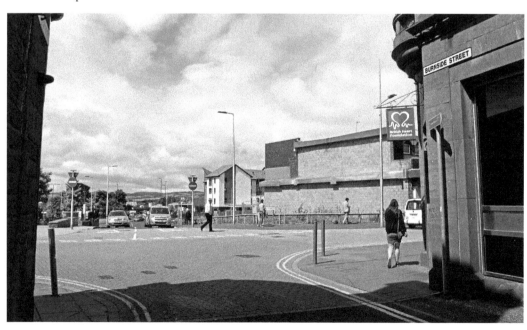

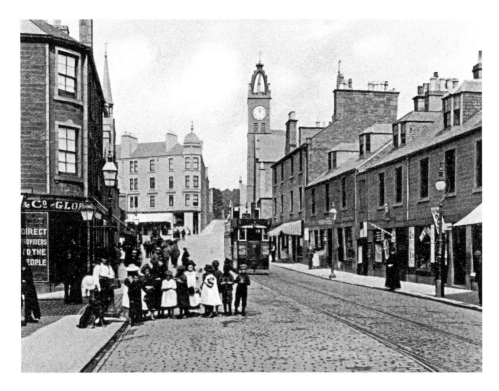

Lochee's Transport

Transport in Lochee was strictly horse-drawn until 1884, when steam-powered trams like the one shown in the archive image were introduced. These were, in turn, replaced by the cleaner and more efficient electric models in 1900. Motorised transport has been a feature of Lochee life for over a century, albeit now constrained by traffic-calming measures and one-way systems, as the recent image shows.

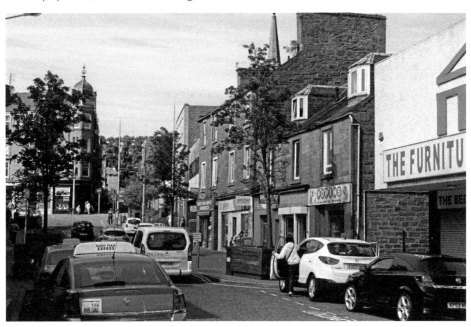

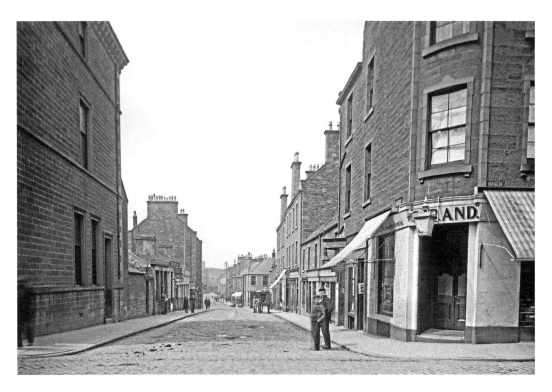

Bank Street

Previously, one of Lochee's most important streets, Bank Street, seen here in the late nineteenth century, linked the High Street to South Road. Redevelopment of this side of the High Street in the 1970s saw the street disappear. Recently however, Bank Street has returned to the map, albeit not quite in its original location, which today is occupied by the shops seen in the modern photograph.

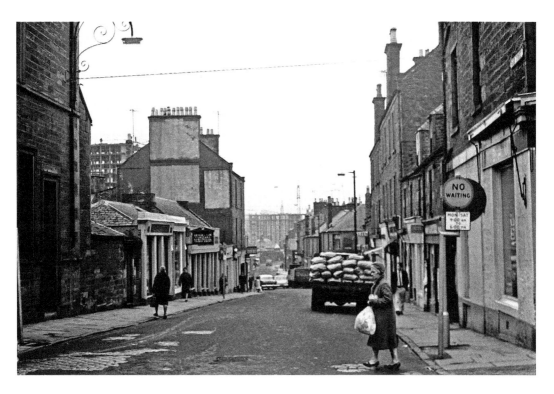

Bank Street – Old and New

Another view of Bank Street – this time in the late 1960s. The redevelopment of South Road was already underway and the construction work can be seen going on in the background. By way of contrast, the modern photograph shows the new Bank Street.

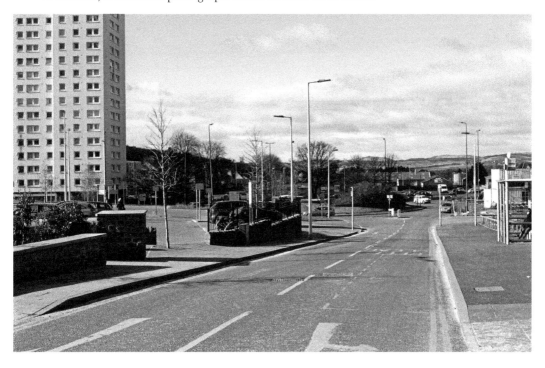

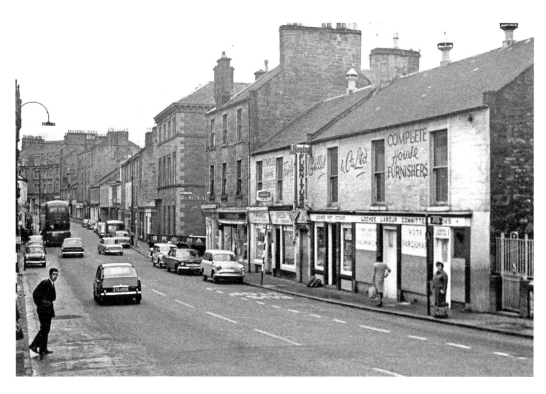

High Street Looking Towards Bank Street
A lorry can be seen turning down Bank Street in this photo, showing its original location. Of all the buildings on this side of the street, only the two relatively modern ones in the distance beyond Flight's Lane survive today.

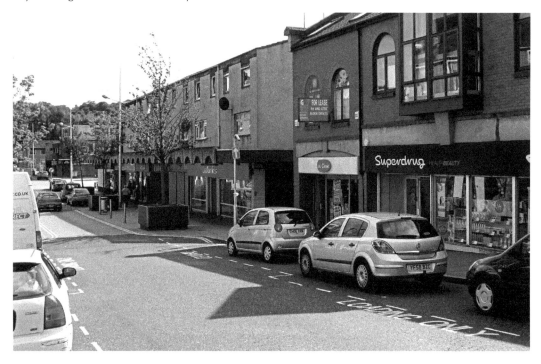

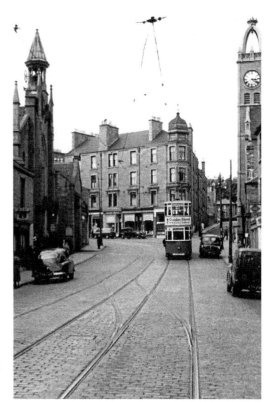

High Street Looking Towards Bright Street
While the distinctive corner tenement at the foot of Bright Street in the centre of this 1950s photograph remains, the two other landmarks dominating the skyline on either side of it – St Luke's and Lochee East churches – have gone in the interim period.

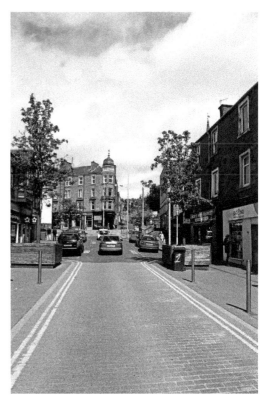

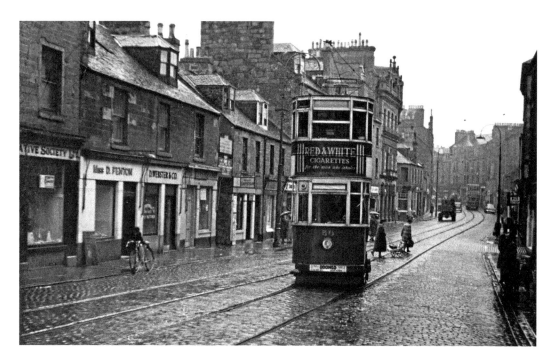

High Street

Of all the businesses visible in this 1956 view, only D. Webster & Co., butchers, still occupies the same shop some half a century later. The buildings to the right of the opening with the advertising boards in the older image were removed in the 1960s to make way for Wm Low's supermarket (now the Furniture Factory).

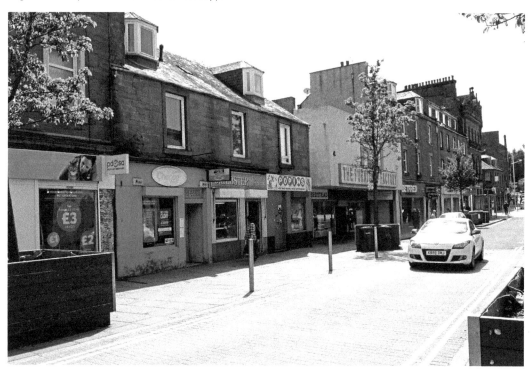

St Luke's Church

The first place of worship on this site in the High Street was a United Secession Church, which opened in 1827. The building underwent expansion and remodelling in 1856. In 1874, the church was acquired by Thomas Hunter Cox and presented to the Church of Scotland. Known as St Luke's, the parish survived for more than a century before merging with Lochee Old in 1985. The building was later demolished.

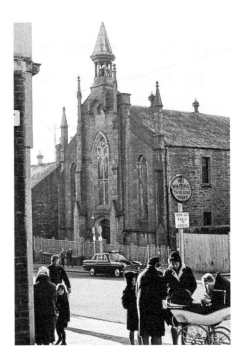

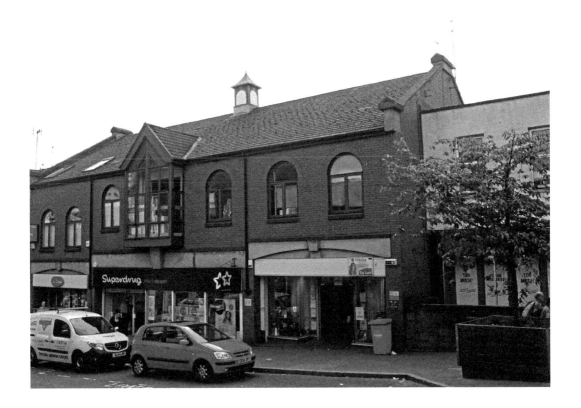

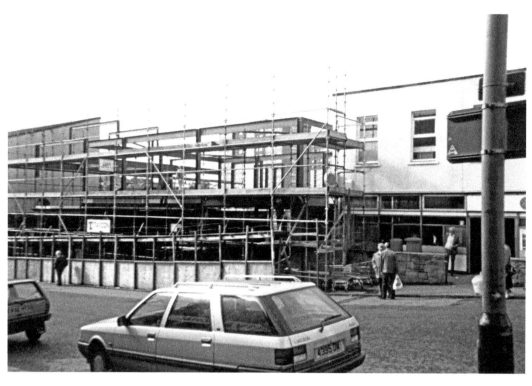

Site of St Luke's and the Post Office
Following the demolition of St Luke's, a building containing new retail units took its place. This photograph from the early 1990s shows it under construction. Visible to the right of the scene is the Lochee post office, which took the place of the old tram depot.

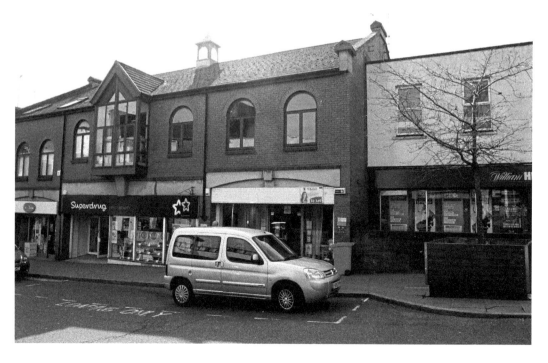

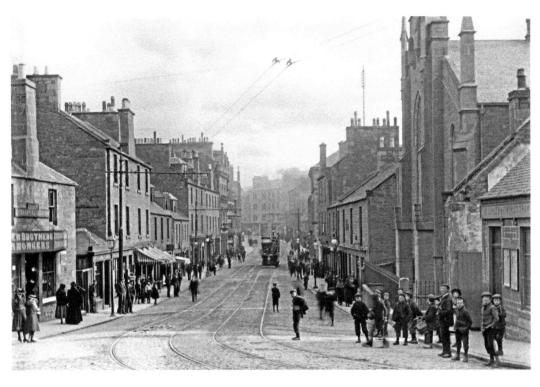

High Street from the foot of Bright Street

This view down the High Street would remain recognisable to a visitor from the late nineteenth century when the earlier photograph was taken, though he or she might wonder where all the people had gone.

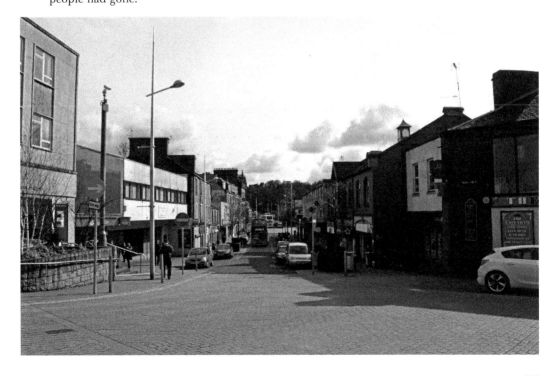

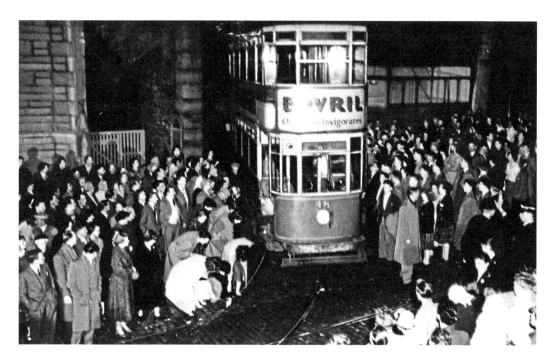

The Last Tram

Dundee's last tram ran on 20 October 1956, arriving at Lochee's tram depot in the early hours of the following morning, where it was greeted by a large crowd. The name of the pub next door to the site of the depot commemorates this event while the depot site itself is now occupied by a bookmakers, having once housed Lochee's post office (*see* page 24).

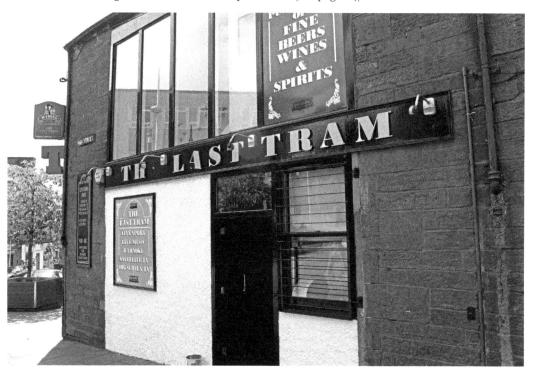

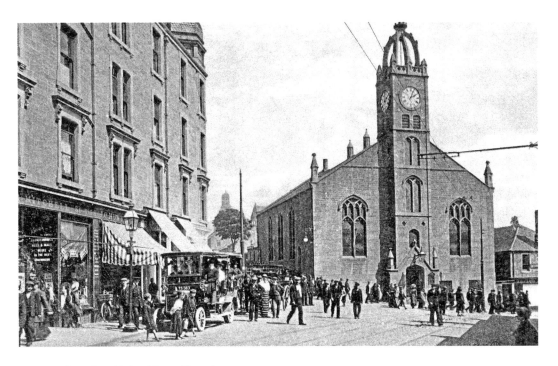

Lochee East United Free Church

Lochee East United Free Church was built in 1847 and was once a distinctive landmark on the High Street – particularly after 1890 when the tower was completed and the clock, which was maintained by the local council, was added. The Woolworths building (now Poundstretcher) that replaced the church also had a public clock at one time, but this has long since disappeared.

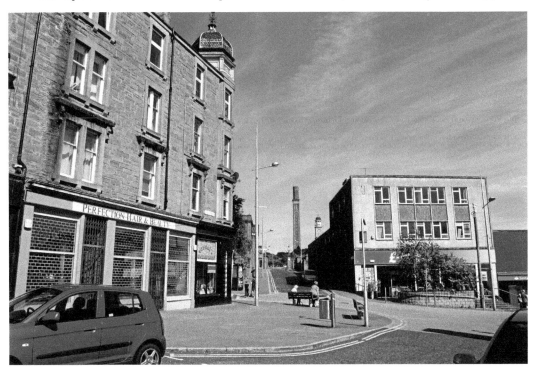

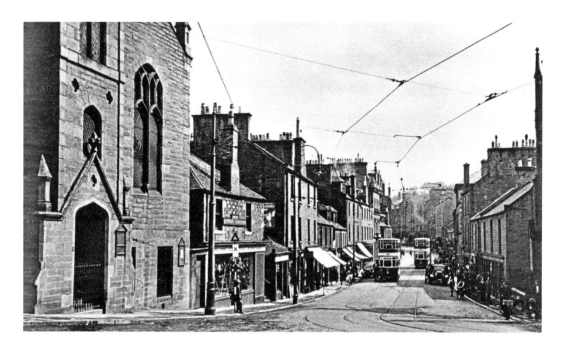

Lochee Literary Association

The upper floor of the building beside the church was once home to the Lochee Literary Association. Founded before Lochee had a library, the association provided access to books and newspapers and staged events in its rooms, which were donated by Thomas Cox of Cox Brothers. More famous in later years for snooker tables than literary discussions, the building and its neighbours were demolished and replaced with Cooper's Fine Fare Supermarket (later the Royal Bank) and Abbey National (now Santander).

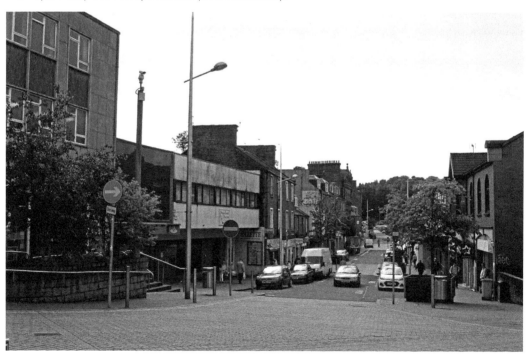

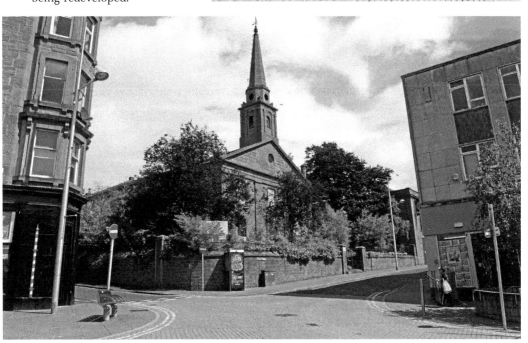

Lochee Old Parish Church

Lochee's original location had made it part of the parish of Liff but, by the late 1820s, it was clear that a chapel of ease would be required for the expanding part of the congregation based in Lochee. Opened in 1830, the church finally became an independent parish in 1880 and survived to celebrate 175 years as a place of worship. The building closed following a union with Lochee West parish church in 2006 and is currently being redeveloped.

29

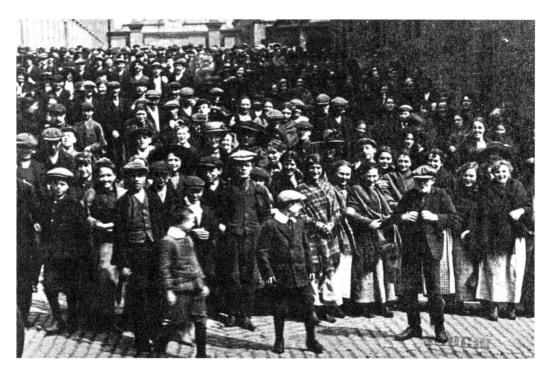

Methven Street

The mass exodus of workers from Camperdown Works down Methven Street was a familiar site in Lochee for more than a century. Previously known as Brown Street, Methven Street was renamed in honour of Eliza Methven, the wife of George Addison Cox, and now provides access to the mixture of housing and retail units that occupy the site.

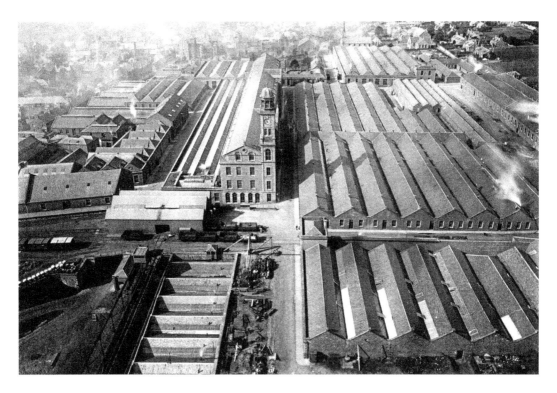

Camperdown Works

Once the largest jute mill in the world with its own branch railway, stables, foundry and fire station, Camperdown Works, at its peak, employed over 5,000 people and occupied more than 30 acres. Now mainly utilised as a retail park, part of the site has been converted to housing and the landmark clock has been retained.

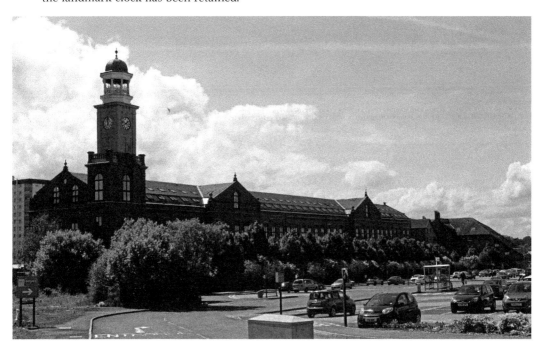

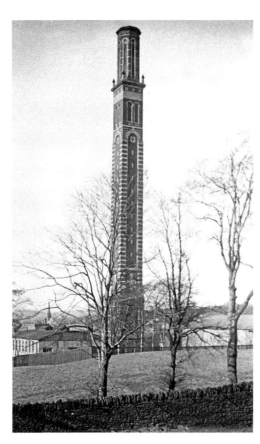

Cox's Stack
Containing around 1 million bricks and standing at 282 feet high, the great chimney of Camperdown Works, known locally as Cox's Stack, was built in a style reminiscent of an Italian bell tower. It remains Lochee's most distinctive landmark, though the decorative turrets that can be seen in the earlier picture have been removed.

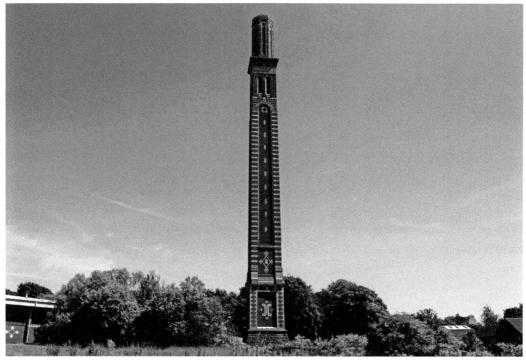

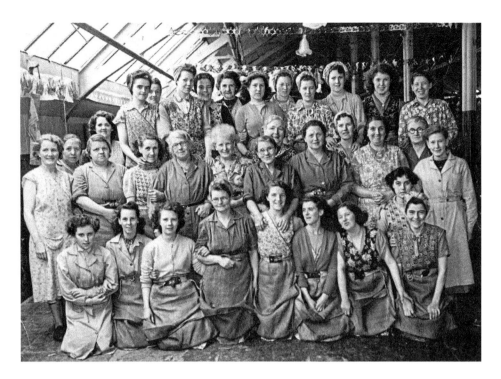

Jute Workers

Women from Cox's mill gather for a group photograph to celebrate the Queen's coronation in 1953. Female workers made up a significant proportion of the workforce in Dundee's jute industry and are remembered today in a sculpture situated at the top of the reinstated Bank Street. The adult figure was based on local woman Stella Carrington who long campaigned for such a commemoration for Dundee's jute workers.

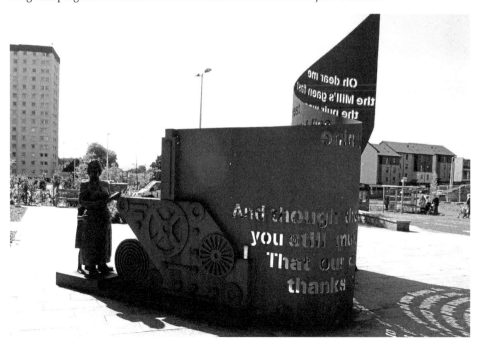

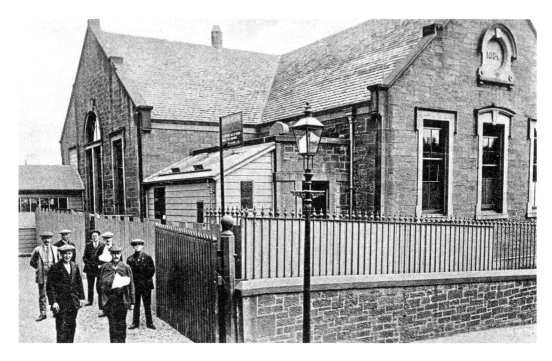

Boys' Brigade Hall, Bright Street

This hall was originally constructed as a school for 'half-timers' – children who spent part of their time in education and the rest working – in this case, in Camperdown Works. During the First World War, as the older picture shows, it was used as a Red Cross Hospital. The building is now home to the 6th/8th Dundee Boys' Brigade.

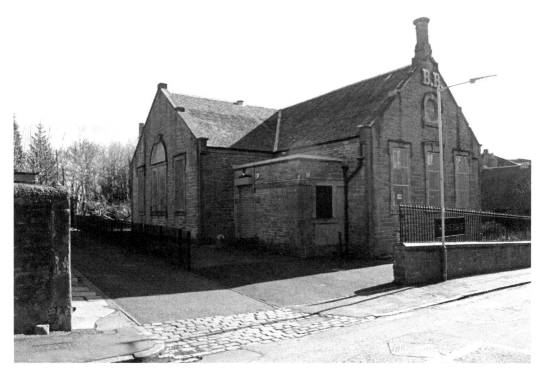

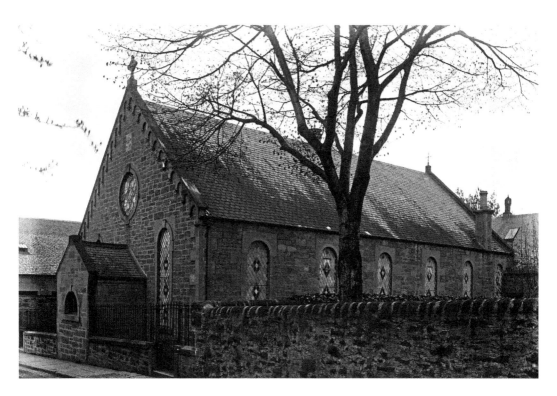

Baptist Church, Bright Street

Lochee's Baptist Church opened in December 1866, having been built at a cost of around £800. At the time the church was built, Bright Street was known as Union Street, but it was renamed Bright Street in 1889 on the death of John Bright of the Anti-Corn Law League. Today, the building is used as the Lochee Centre of the Central Baptist Church.

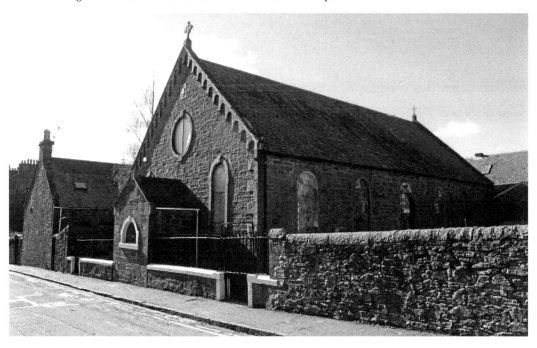

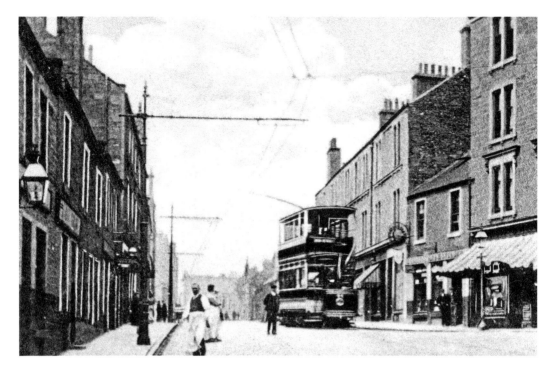

West High Street

This view has changed little since it was captured in the early years of the twentieth century and would probably be considered unremarkable by locals either then or now. It could nonetheless surprise a stranger who might not expect the High Street to continue round the corner. The town of Kirkcudbright is famous for having an L-shaped High Street but Lochee's main street – which follows the route of the old Newtyle Turnpike Road – changes direction more than once.

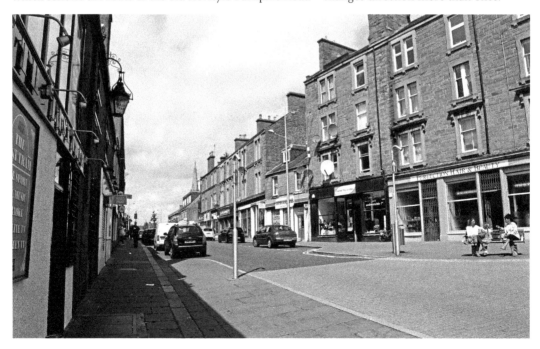

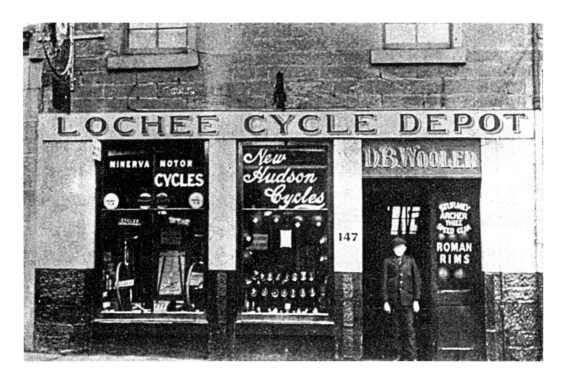

Wooler's Cycle Shop

For most of the twentieth century, Wooler's cycle shop occupied the premises at No. 147 High Street. The penny-farthing sign in the top left-hand corner of the older image is long gone but a close examination of the modern photograph reveals that the bolts that once fixed it in its place are still in the wall.

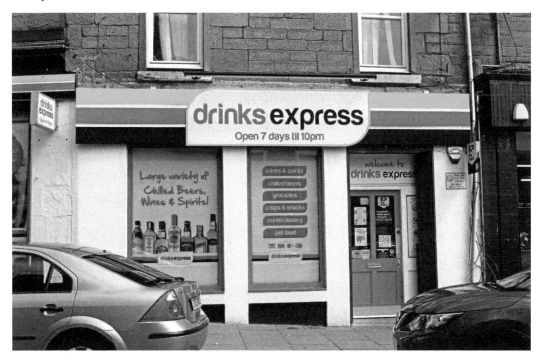

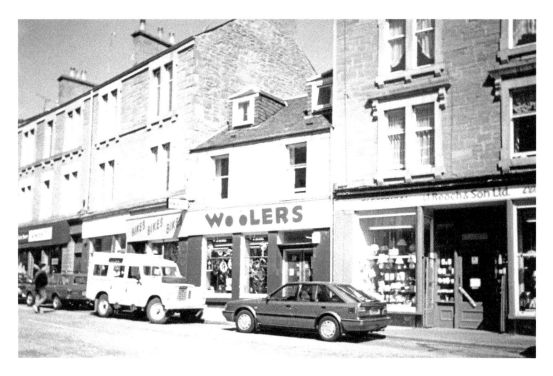

High Street

The increase in the number of out-of-town shopping centres and the advent of internet shopping, in the period since this 1991 view was captured, has seen many long-established businesses – such as Wooler's and Reoch's electrical store – disappear from the High Street. It is telling that the two businesses that survive from the earlier view – an opticians and a launderette – are among those that are less susceptible to these trends.

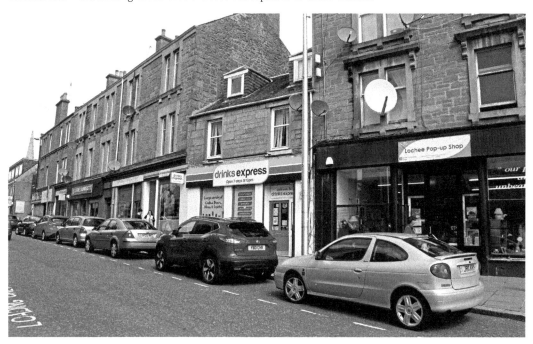

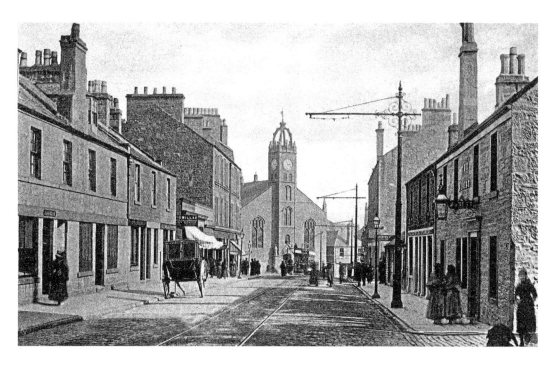

High Street at Sinclair Street

Leading off to the right beside the Albert Bar in both of these images is the opening of Sinclair Street. This street, which was known as Small's Lane in the nineteenth century, once linked the High Street to Mid Street (later known as Lorne Street).

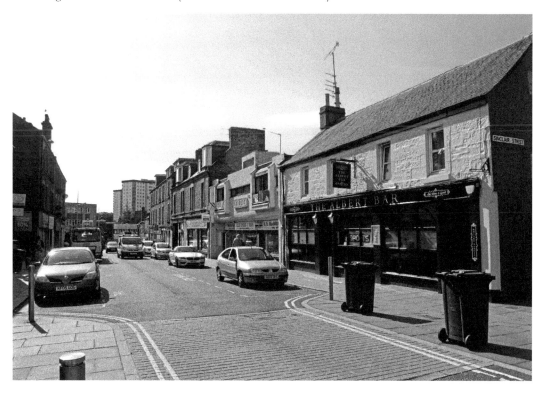

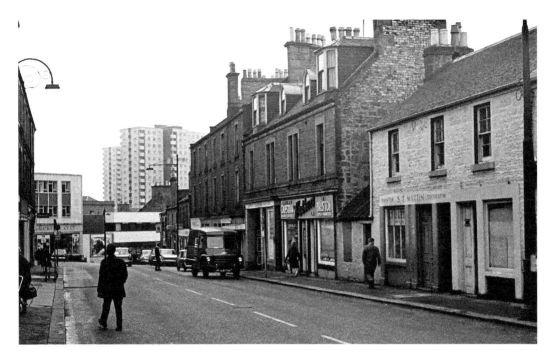

High Street

The old building on the right-hand side of this photograph is the only one in this late 1960s view that does not survive today. The replacement building originally provided premises for some of the businesses left 'homeless' by redevelopment elsewhere in Lochee: Quinn's decorators, Martin the fishmonger and MacDonald's the butcher all moved from further down the High Street while Duirs the barber from Bank Street moved to the upstairs shop.

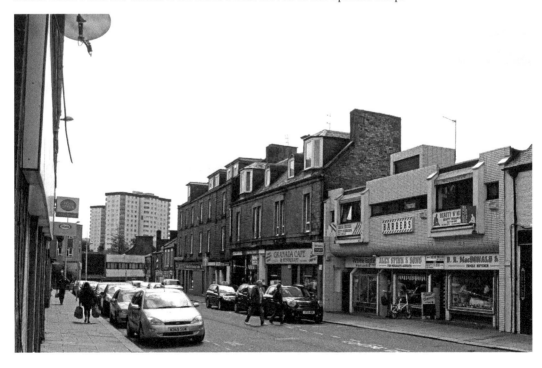

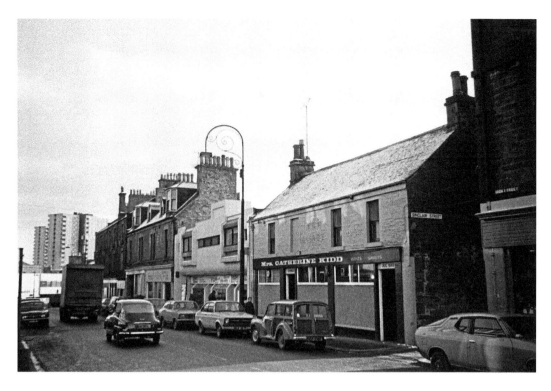

The Albert Bar

The Albert Bar has been a fixture of Lochee life for more than a century and a half. Previously known as the Albert Hotel, at one time, it had its own brewery and stables. This led to the pub being nicknamed 'The Brewers' in the nineteenth century. Local people still seem averse to using the pub's official name and today it is usually known as 'Kiddie's' after the Kidd family who ran the pub for many years.

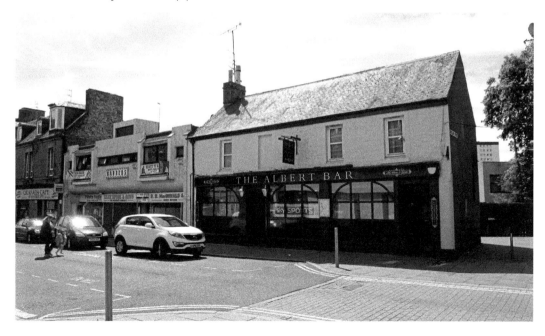

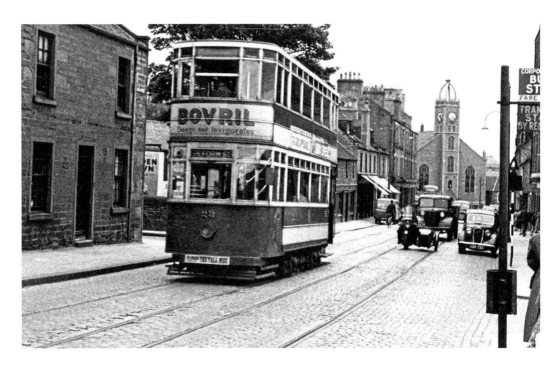

High Street at Nicoll's Lane

Though at first glance this section of the High Street appears to have altered less than the rest, there have still been several changes since this photograph was taken in 1955; in particular, all of the buildings in the foreground on the left-hand side have been replaced. The name of the café bar however provides a link with Lochee's past.

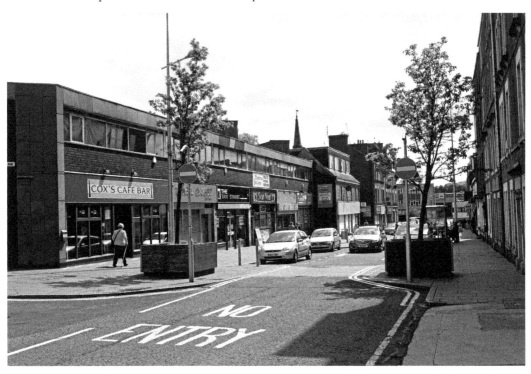

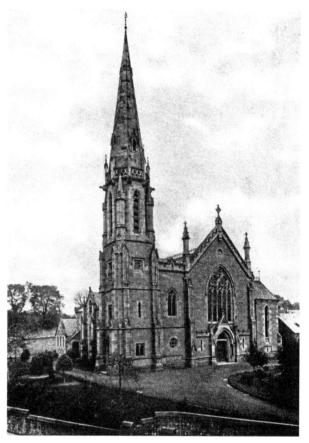

Lochee Parish Church

This church opened in 1871 and has been home to various denominations, though it is now part of the Church of Scotland. Prior to its construction, part of the site was occupied by the summer residence of Robert Stephen Rintoul, the founding editor of the *Spectator* magazine, which today is the oldest continuously published magazine in the English language. Previously known as Lochee West, the church became known as Lochee Parish Church following the unification with Lochee Old and St Luke's in 2006.

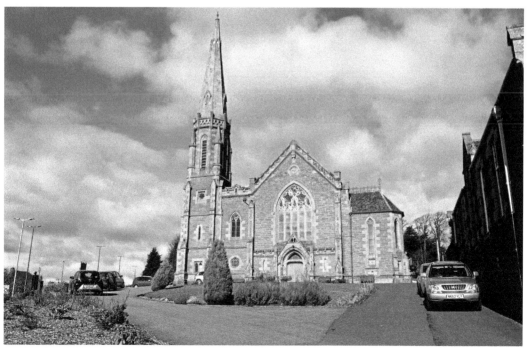

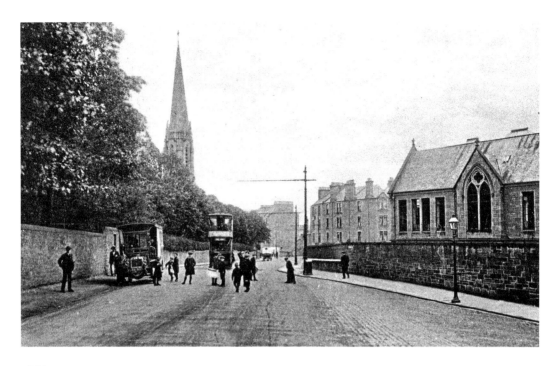

Birkie Bus

On the left of this 1913 view, the 'Birkie Bus' can be seen. Records show that this particular 16-horsepower motor charabanc was painted dark green and was owned (and no doubt built) by the firm of W. Raikes Bell who first manufactured their Werbell motor cars in Dundee in 1907. The firm went out of business in 1914, but it is interesting to speculate how Dundee's future might have been changed had it been successful.

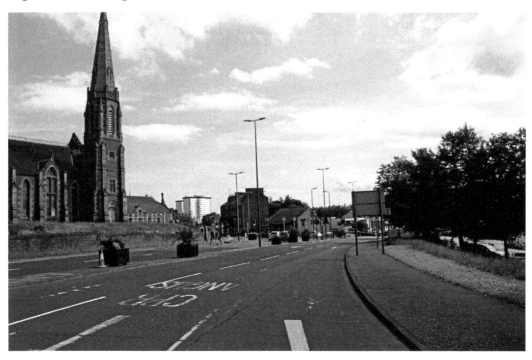

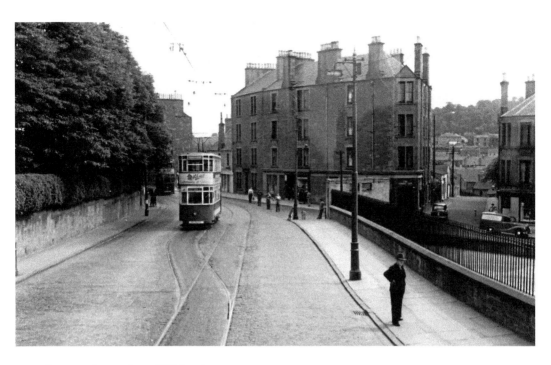

Stewart Street from Liff Road

This view shows the junction of the High Street and Liff Road near the tram terminus, with Stewart Street running downhill to the right of the picture. The bypass cut through this scene, leading to the demolition of many of the buildings seen here and the interruption of the seamless link between the High Street and Liff Road.

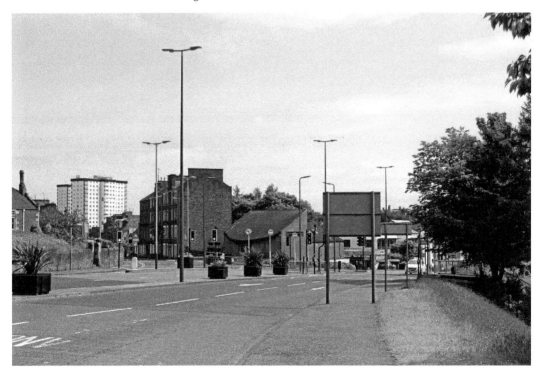

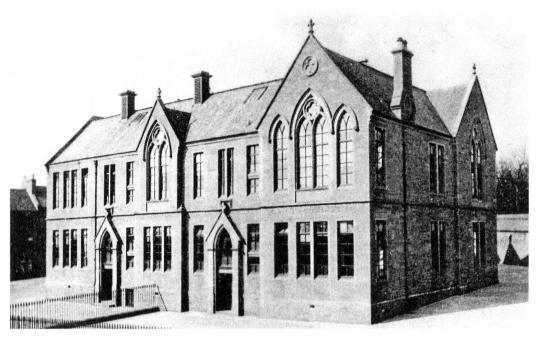

Liff Road School

Liff Road school was officially opened on 1 December 1891 and survived until the early 1970s when it was demolished. The new Lochee police station was built on the site.

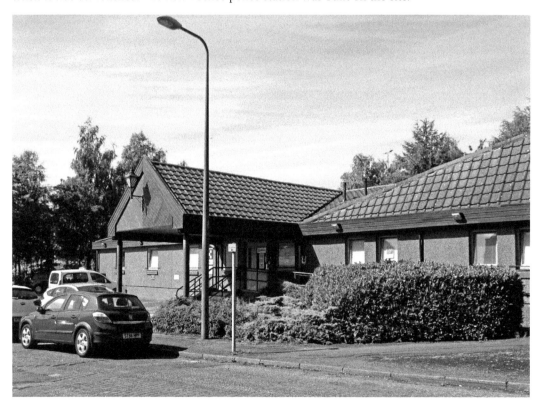

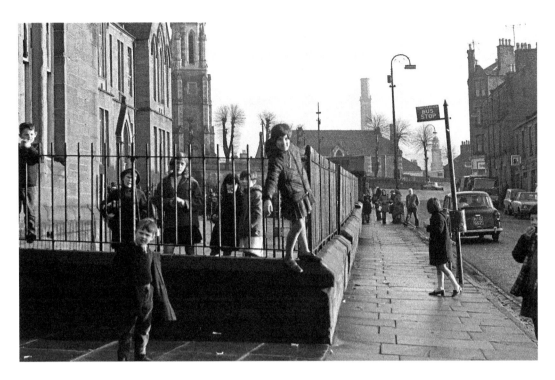

Liff Road

The schoolchildren in this view of Liff Road from around 1970 no doubt patronised the many local shops in the area, including Frank Davie's ice-cream shop, visible in the distance at the top of Stewart Street. Following its demolition in the 1970s, Davie's moved to premises at the junction of High Street and Marshall Street. Around the same time, the opening of the bypass transformed this part of Liff Road from a busy traffic route into a cul-de-sac.

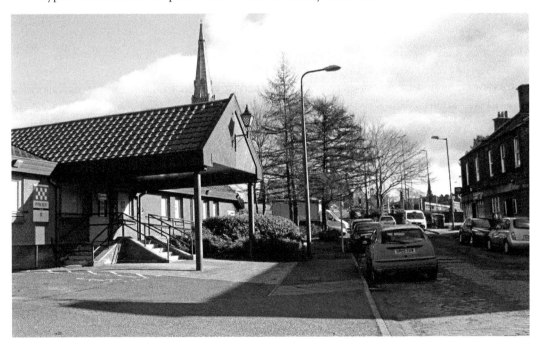

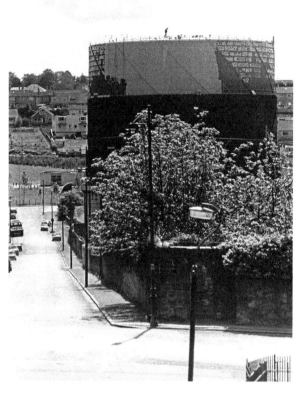

Perrie Street

Once called Archibald's Lane, Perrie Street takes its name from Bailie James Perrie, a baker by trade who served as Lochee's representative on the town council continuously from 1876 to 1917, earning him the nickname the 'Provost of Lochee'. The large gas tank, or gasometer, in the earlier picture was a Lochee landmark for decades but modern pipe technology has rendered such structures obsolete.

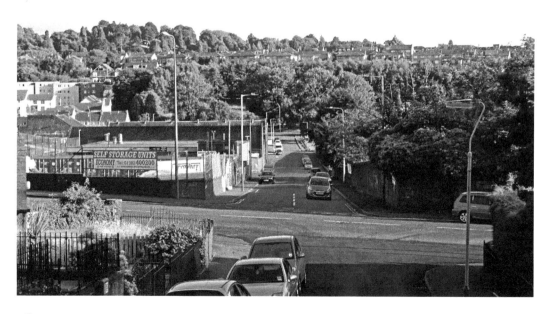

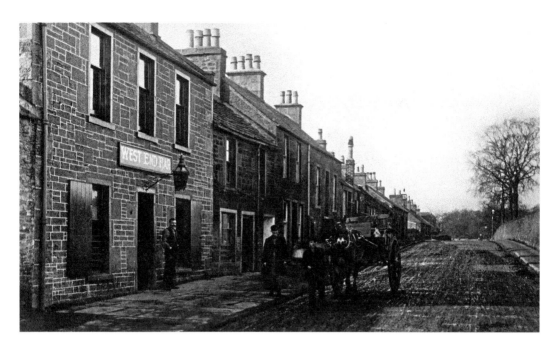

The Whip Inn, Liff Road

Named the West End Bar in this early twentieth-century photograph, this old coaching inn on the road between Dundee and Liff is still a popular venue for drinks and meals. The expansion of Lochee has probably meant that locals outnumber weary travellers among its patrons these days, but its history is commemorated in the name that it bears today – The Whip Inn.

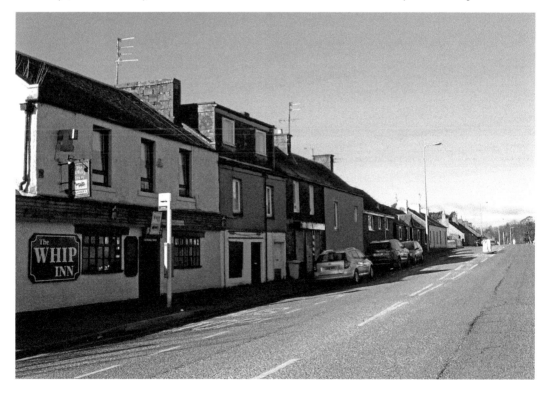

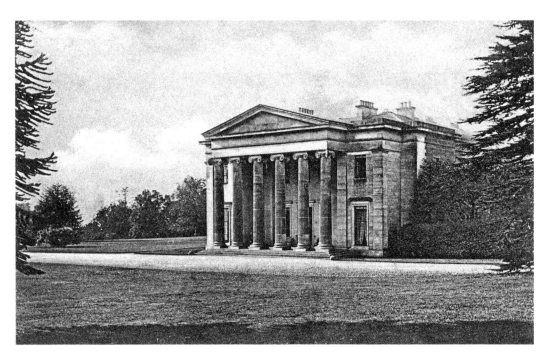

Camperdown Park

Originally known as Lundie, the estate of the Duncan family was later renamed in commemoration of Admiral Adam Duncan's victory against the Dutch at the Battle of Camperdown in 1797. Camperdown House, shown here, was not built until the 1820s, several years after the admiral's death. The estate was bought by the Corporation of Dundee in 1946 and was officially opened as a public park by Princess (later Queen) Elizabeth.

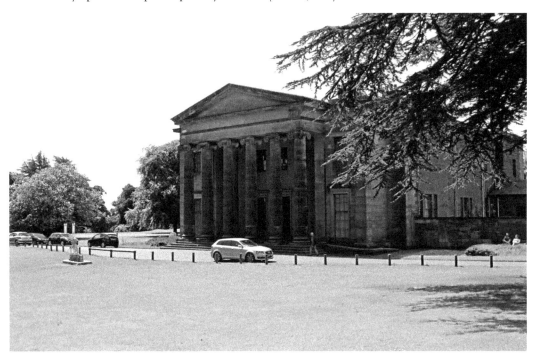

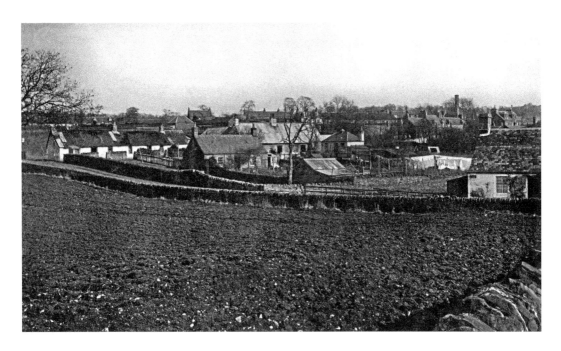

Buttar's Loan

This rural scene at what is now Buttar's Loan, gives a flavour of old Lochee. The location can be identified by some of the buildings towards the top right of the older photograph, which still exist off Pitalpin Street, though the built-up nature of the area today means that they are not visible in the modern image.

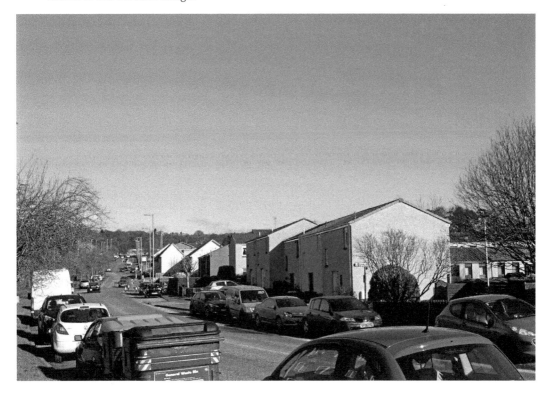

51

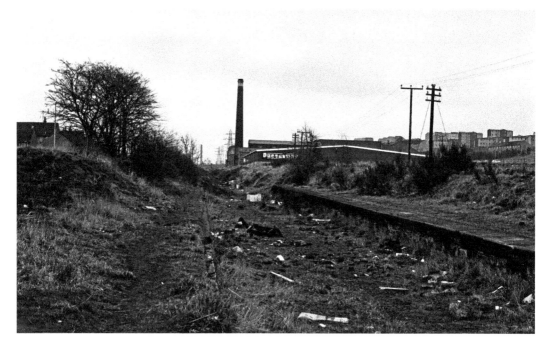

Dundee Floorcloth and Linoleum Co. Ltd, South Road
The older view here is taken from the site of Liff railway station (which, despite its name, was not located in the village of Liff), looking towards the former premises of the Dundee Floorcloth and Linoleum Co. Ltd on South Road. The factory site is now occupied by a Tesco store. The modern photograph is taken from a point nearer to the factory site. The Queensway building in the earlier picture is now occupied by Sterling Furniture.

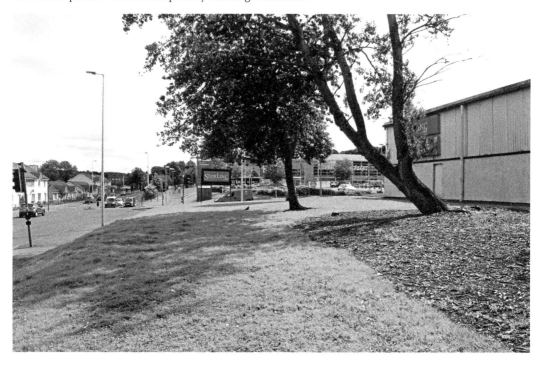

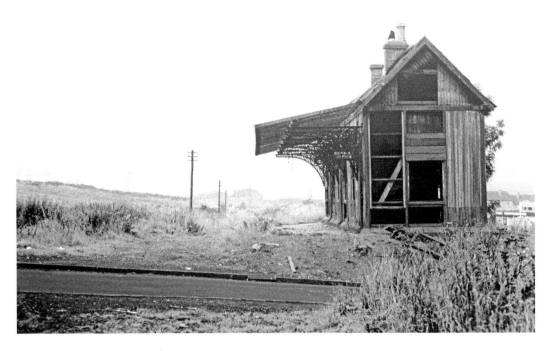

Lochee West Station

No trace remains of Lochee West (or Camperdown) station at Elmwood Road, seen here after its closure. The cycle path visible in the foreground of the modern picture follows the original railway line and shows where it would have crossed the road and a gate would have been closed to allow trains to pass.

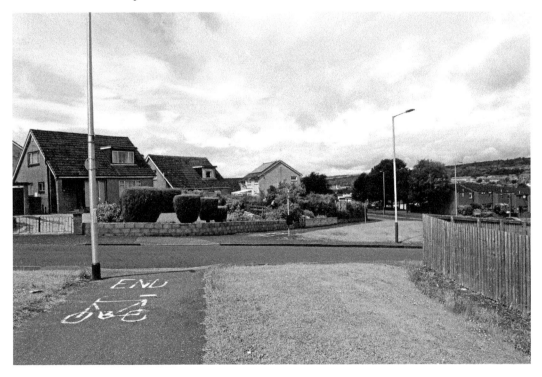

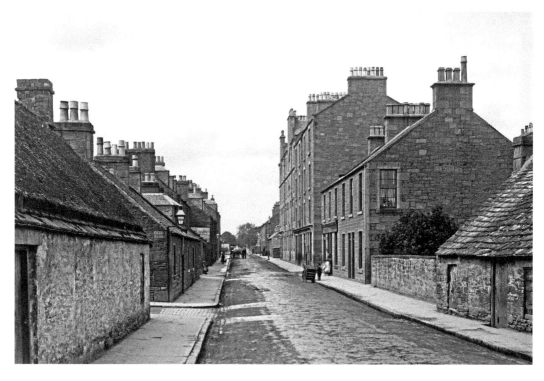

South Road

The one surviving building on the north side of the street helps to pinpoint the position of this late nineteenth-century view of South Road. The two lanes, whose openings can be seen on the south side, are Sharp's Lane (which still exists but no longer extends to South Road) and Yeaman's Lane, which, in much widened form, can be seen in the modern picture.

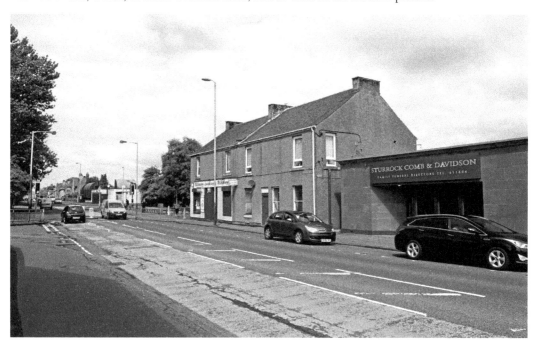

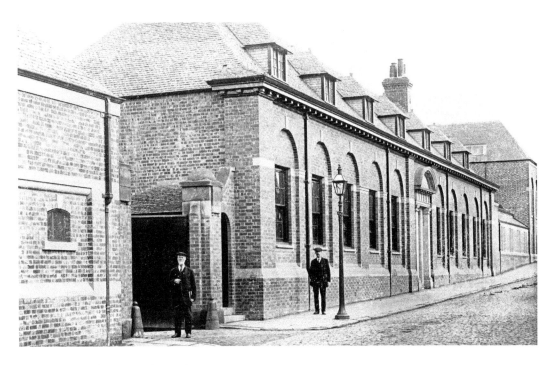

East Brothers, South Road

Part of this building on South Road dates back to the 1860s when it was occupied as a power loom factory by Messrs John Potter & Co. The building was later expanded and given a new frontage after it came into the hands of cabinetmakers East Brothers, who made furniture there from 1905 until 1987.

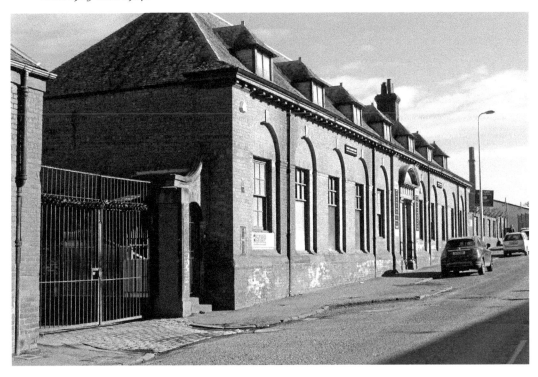

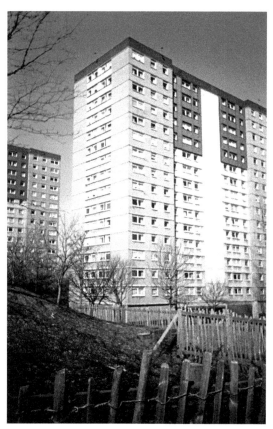

South Road 'Multis'

Twenty-five years separate these two views taken from the same corner at the Kirk Street flats, looking towards South Road, but the scene could hardly be more changed. In the 1960s and 1970s, multistorey blocks were seen as a solution to housing problems, and four such blocks were built at South Road. The two seen here however – Sharps Court and Yeaman's Court – were demolished in favour of modern housing on a more human scale.

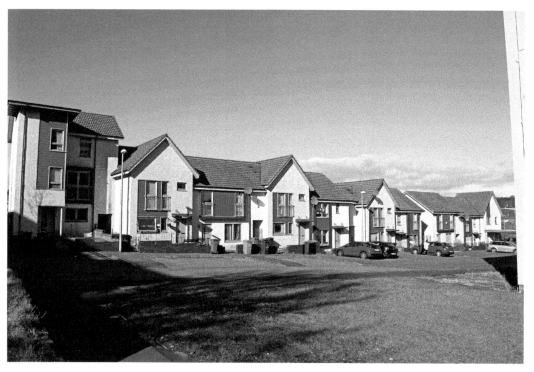

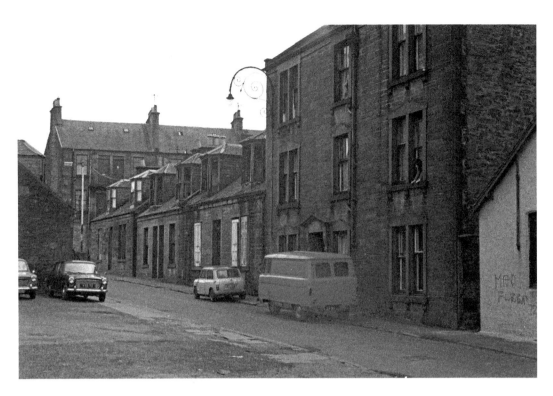

Kirk Street

Shown on old maps in the more anglicised form of Church Street, Kirk Street once comprised northern and southern sections on either side of South Road. This photo shows the northern part shortly before demolition. Just visible at the right-hand side is the building that housed the Bog Mission. The effects of Lochee Burn in the vicinity gave the area the nickname 'The Bog'. As the modern image portrays, Kirk Street is now given over to industrial use.

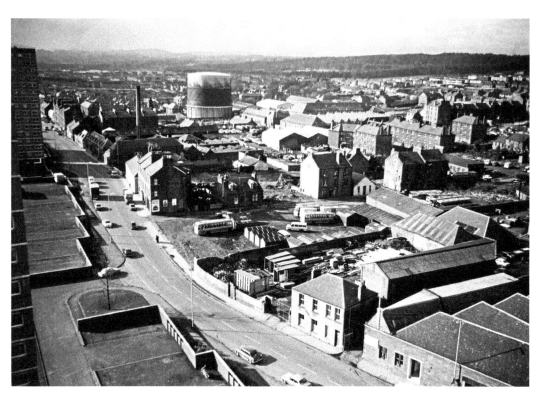

South Road

An aerial view of South Road in the 1970s shows Kirk Street in context while Thomas Graham's builder's merchants and Thomson's buses take up the foreground. The recent image, taken from ground level, shows how the whole appearance of the area has altered.

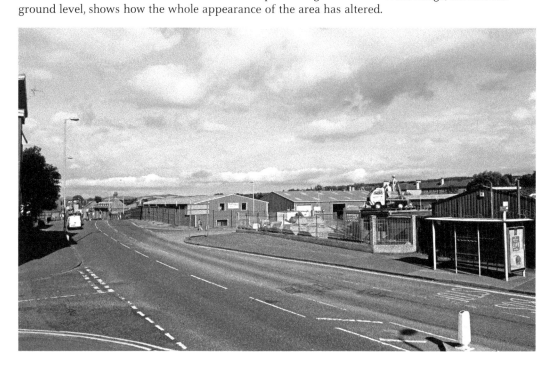

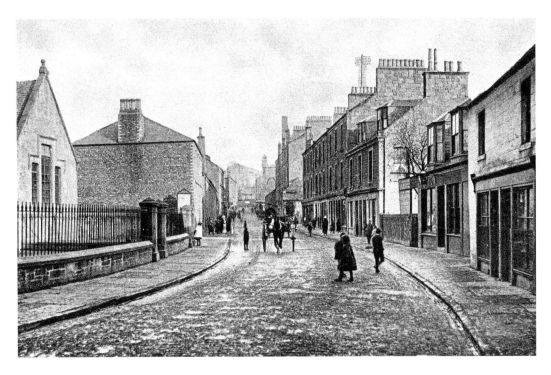

South Road

The village feel of this part of South Road is something that has been lost over time. South Road School is among the vanished features on the left-hand side of the older image, while leading off to the right, Wilson Street can be seen, which once linked South Road to Balgay Street.

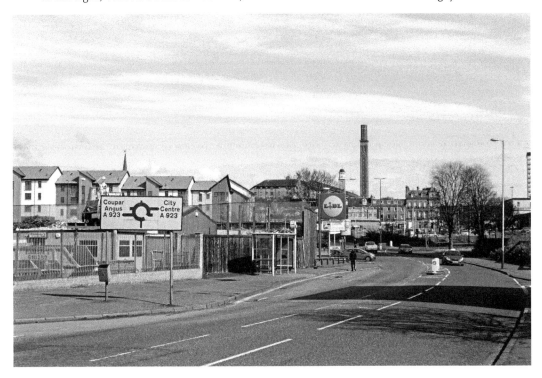

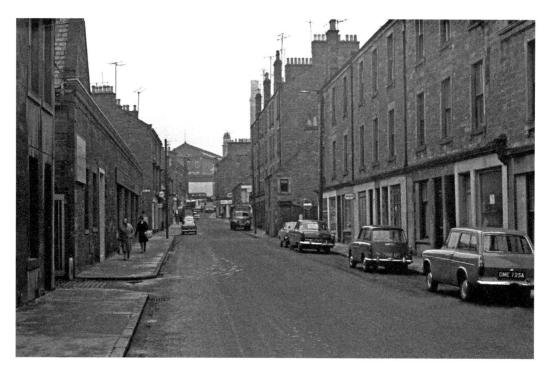

South Road Looking to Bank Street

This late 1960s photograph shows how Bank Street and South Road together formed one continuous route to the High Street. The white building in the distance is Wm Low's supermarket (now the Furniture Factory).This continuity was completely lost only a few years later with the removal of Bank Street and construction of the bypass.

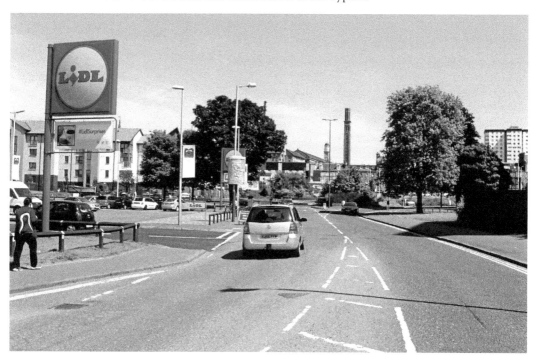

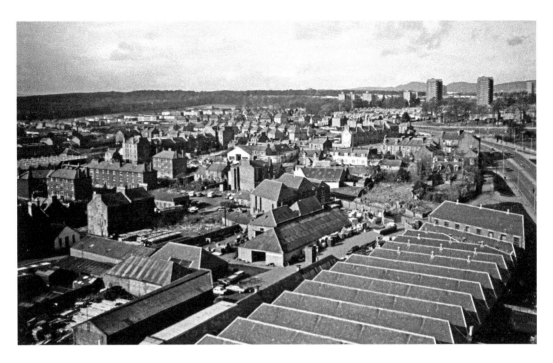

Ancrum Works, South Road

The series of pitched roofs visible in the earlier image belong to Ancrum Works, which was a carpet factory operated by George Stevenson & Co. Stevenson was a local councillor after whom Stevenson Street in Lochee is named. In 1945, the building was acquired by the British Fish Canning Co. Ltd and in the 1960s by Thomas Graham & Sons, builder's merchants. It was latterly occupied by the Parrot Pine Co. before being demolished to build a Lidl store.

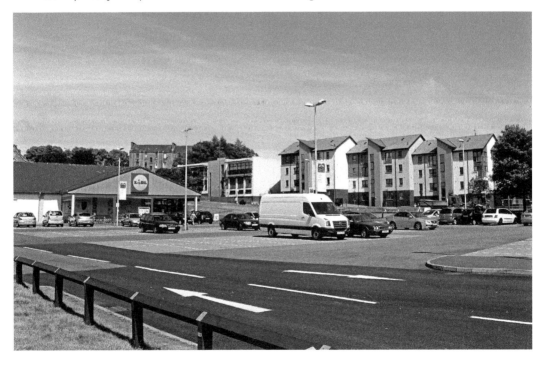

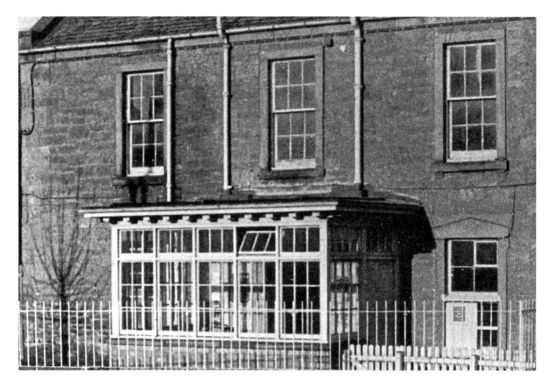

Lochee Police Station

Dating from the 1860s, this building was Lochee's police station for more than 100 years; it gave its name to the adjoining Station Lane. The station has been demolished but the wall that once supported the railings, visible in the earlier picture, has survived, and it seems likely that it is the same tree that can be seen in both pictures.

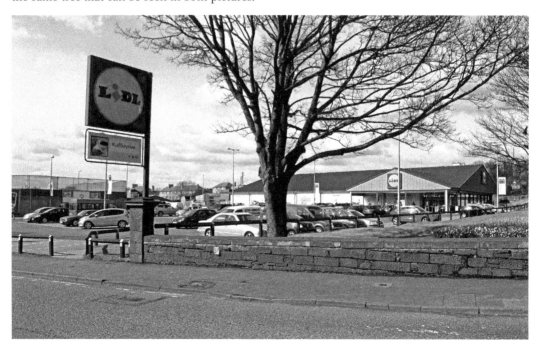

Stewart Street

After the construction of the bypass, some streets like Bank Street disappeared off the map altogether while others such as Balgay Street, Sinclair Street and Stewart Street remained in truncated form, but were robbed of their original importance and function. These images show what remains of Stewart Street. The pub on the left of the earlier photograph has now been converted into housing.

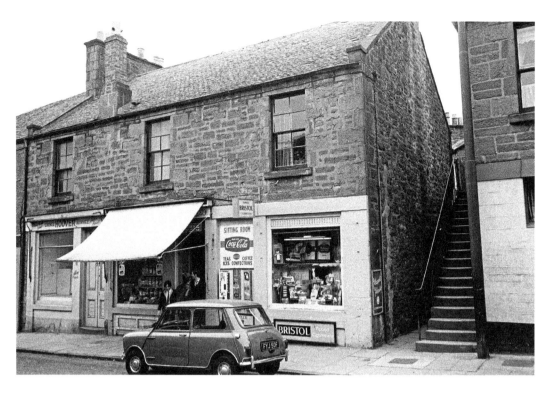

Vettraino's, No. 9 South Road

Next door to the Central Bar on South Road was Frank Vettraino's confectionery shop. Part of the pub is visible at the right edge of the older photo. This area of South Road was demolished to make way for the bypass and the modern photograph shows the same location today.

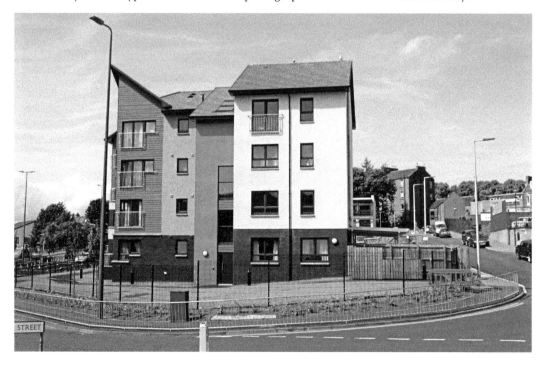

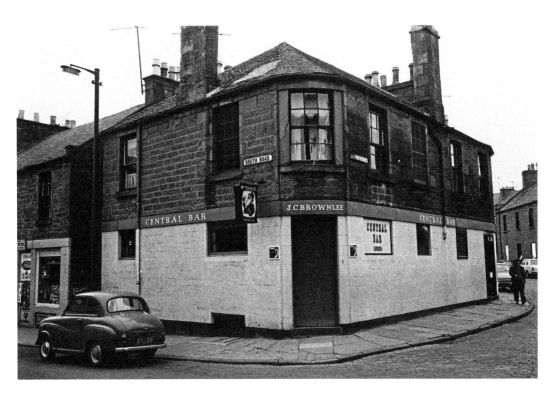

Central Bar

This once well-known pub was located at the corner of South Road and Lorne Street near the foot of Bank Street. The landlord at the time of this photograph, James Carrie Brownlee, had succeeded his father James Kerr Brownlee in the role. Following the demolition of the Central Bar, Brownlee opened the Planet Bar further along South Road (seen in the lower picture). The Planet was later run by his son, the late James John Brownlee.

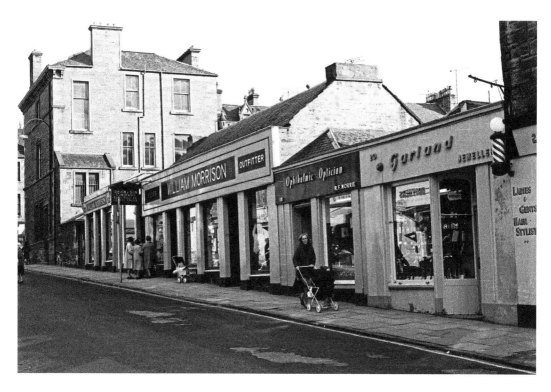

Bank Street

Another comparison of the two Bank Streets – this time looking towards the High Street and the Royal Bank building that gave the street its name. The change in shopping habits is shown in that the various small businesses of the old street are replaced by the single supermarket of the new.

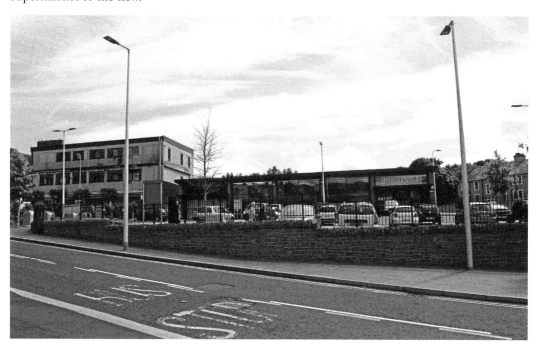

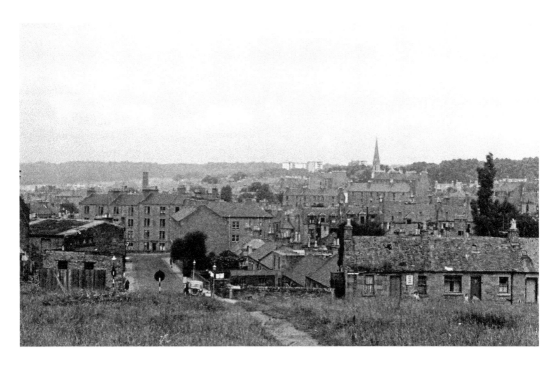

St Ann Street

The older scene here looks across Marshall Street down St Ann Street to Balgay Street. So many of the buildings have gone that it might be difficult to relate this image to its modern equivalent, but a fragment of St Ann Street still exists in the shape of the brightly coloured building partly hidden by trees. This building can be seen more clearly and in its unadorned form in the older image.

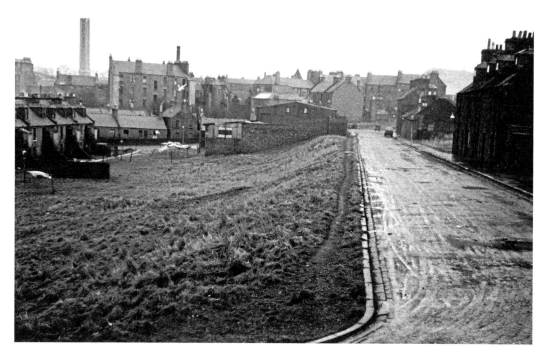

Marshall Street

A short section of Marshall Street remains today, stretching from the High Street to the Lochee bypass but, as the older photograph shows, it was once a much longer street. Redevelopment prevents the modern image being taken from exactly the same spot, but the position of surviving part of the street helps to pinpoint its location.

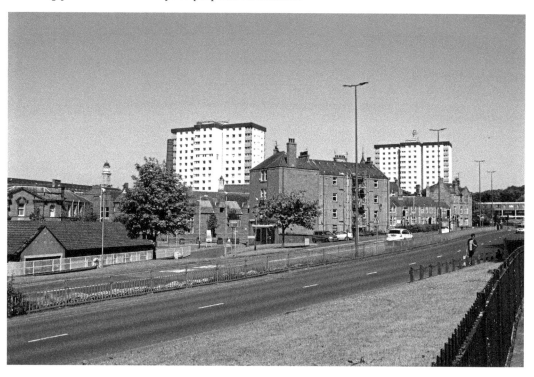

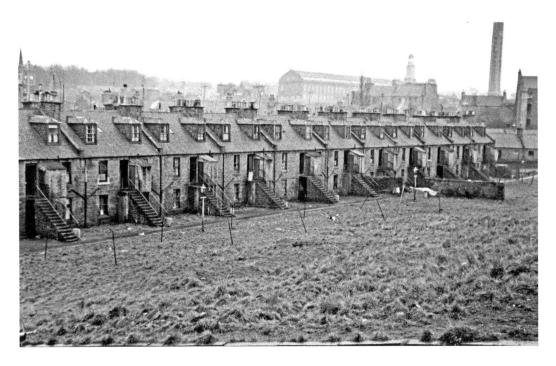

Tipperary

In the nineteenth century, the high concentration of Irish immigrants in the area around Albert Street (later Atholl Street) led to it being nicknamed 'Tipperary'. The entire area was demolished in the 1960s but the name of Atholl Street was retained for the new flats built on the site. The Lochee landmarks of Cox's Stack, and the clock tower clearly visible in the older photograph, can be seen through the trees in the modern image.

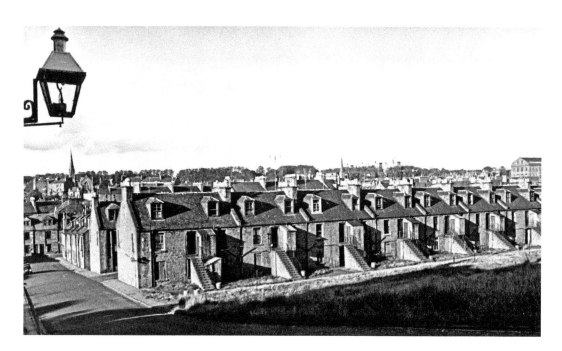

Tipperary from Balgay Street

The older image here is both taken from and looking towards Balgay Street, which was an L-shaped street that ran downhill from Marshall Street then turned right until it met St Ann Street where a small part of Balgay Street remains today. Leading off to the right from Balgay Street is Atholl Street. The recent view is taken from roughly the same position as the earlier one and shows the flats built in the late 1960s to replace Tipperary.

Kirk Street

While the northern portion of Kirk Street follows its traditional route, South Church (or Kirk) Street, which once continued its line from South Road to the railway line, has vanished. In its place are the Kirk Street flats, seen in the older picture under construction in 1972 and recently given a colourful makeover.

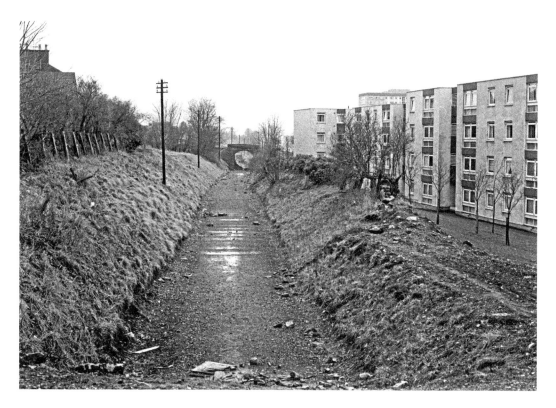

Dundee to Newtyle Railway

Despite closing to passengers in 1955, the remains of the Lochee section of the Dundee to Newtyle railway were visible for decades afterwards, as this photograph at Atholl Street shows, while a path still traces out its route today.

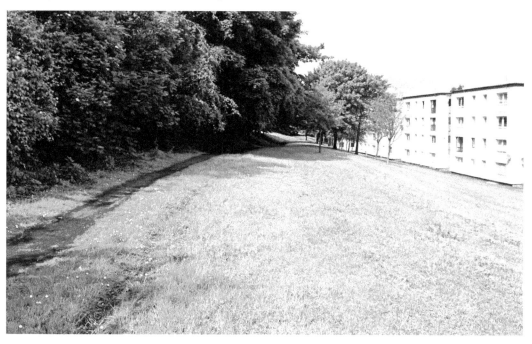

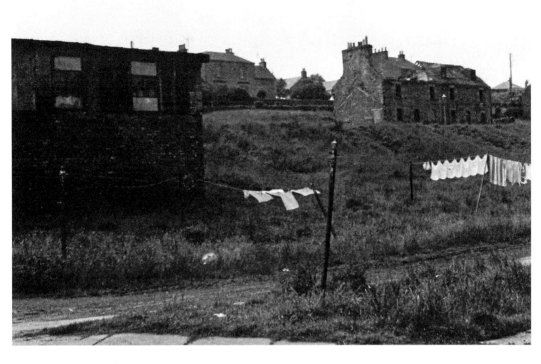

Maloney's Park

The patch of grass behind Tipperary was known by the suitably Irish-sounding name of Maloney's Park. This view looks across Maloney's Park from St Ann Street up towards Marshall Street.

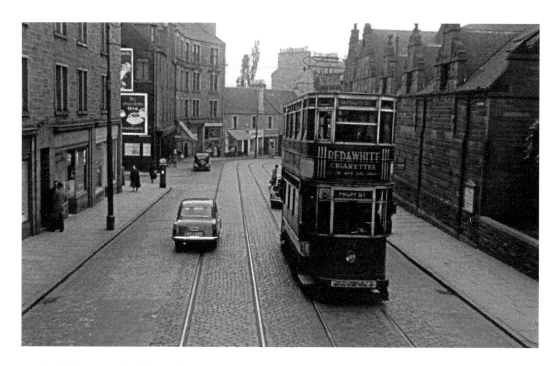

Lochee Library and Public Baths

Thomas Hunter Cox, of Cox Brothers, left a bequest to establish a library and public baths at Lochee. The Jacobean-style building, designed by James Murray Robertson, was erected in 1894 and the reading room and baths opened the following year. The lending library followed in 1896 when Cox's trustees granted a further £500 for books. In 1911, the building was extended to a design by James Thomson. In 2016, the swimming baths reopened after a £1 million revamp.

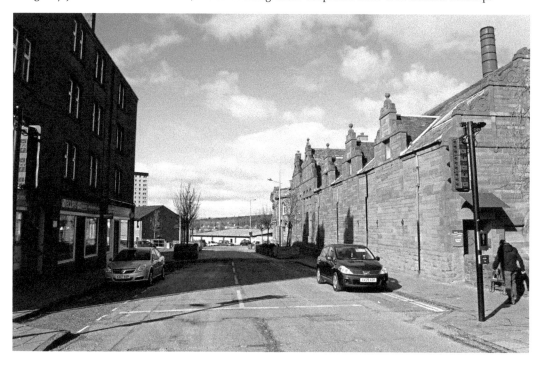

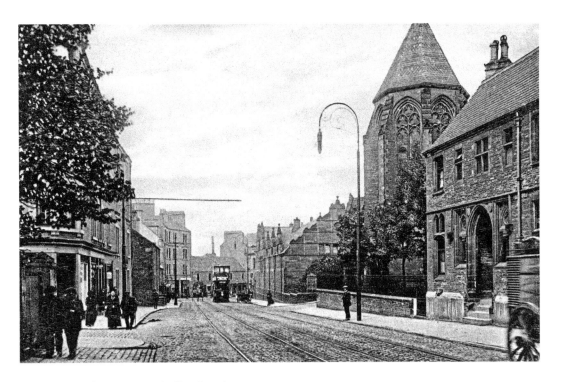

St Mary's Roman Catholic Church

Commonly known as St Mary's Lochee, the Immaculate Conception Church was opened in 1866 to cater for Lochee's growing Catholic population in the wake of Irish immigration in the years after the Great Famine. The architect was Joseph Hansom, inventor of the Hansom cab. After the church was built, nearby Matthew's Lane became known as St Mary's Lane. Still used as a place of worship, the church's 150th anniversary was celebrated with a special Mass in May 2016.

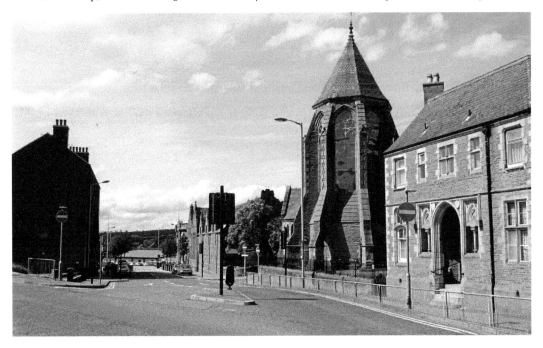

75

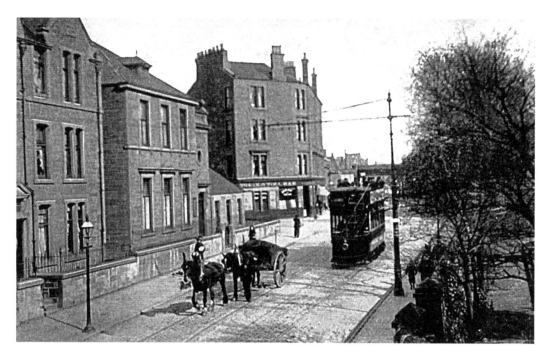

High Street from Gibb's Lane

This view looks from the foot of Gibb's Lane towards the railway bridge. The building next to the tenement on the left of the archive image was once home to the YWCA and later the Lochee Boys' Club. The site is now occupied by the Lochee Community Garden. Beyond this can be seen the tenement that contained the Old Toll Bar. After its demolition, the contents of this pub were on display at Dundee's museum for many years.

Gibbs's Lane

Gibb's Lane, with its fine corner tenement visible in the older image, once stretched from the High Street across the railway line to Ancrum Road where part of it still exists. The High Street end was demolished in the 1970s to make way for the bypass. On the left of the picture is the original boundary wall of St Mary's Infants' School. The school itself was demolished in 2016.

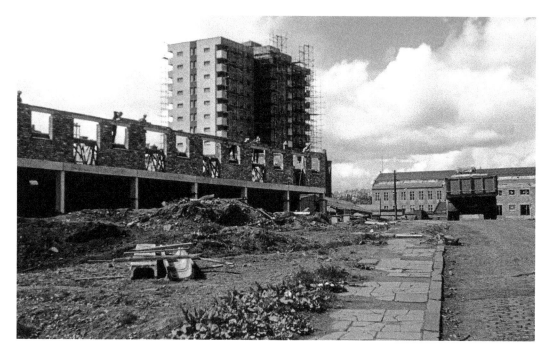

Whorterbank

Like Tipperary, Whorterbank was once a heavily populated working-class area consisting mainly of two-storey buildings. The original street named Whorterbank stretched from the High Street to Burnside Street and can be seen at the right-hand side of the older photograph, which was taken during the area's redevelopment in the late 1960s. The trend at that time was for considerably taller buildings than those that were being replaced.

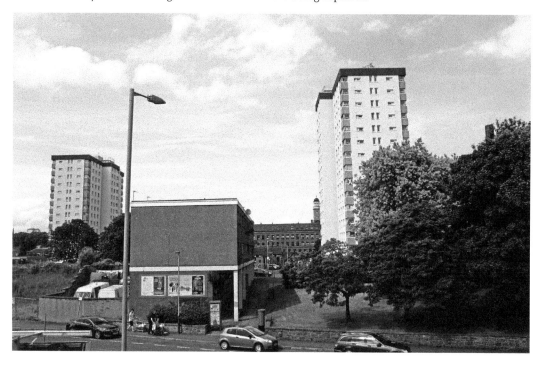

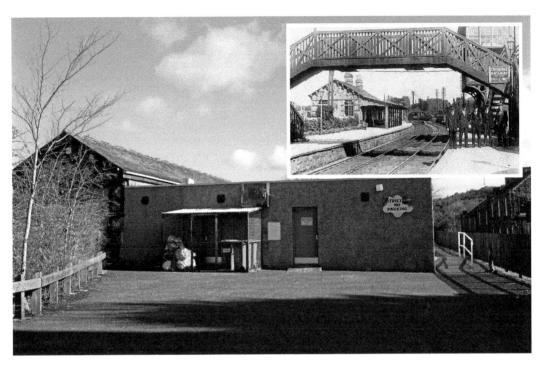

Lochee Railway Station

The Dundee and Newtyle railway opened in 1831 and thirty years later a deviation was added, which avoided the steep incline that took it through the Law Tunnel. This brought the line to Lochee and saw the addition of three new stations at Lochee, Lochee West and Liff. The railway has long since gone, but the Lochee station building, designed by Edinburgh Architect Sir James Gowans, survives and is now home to the Lochee Burns Club.

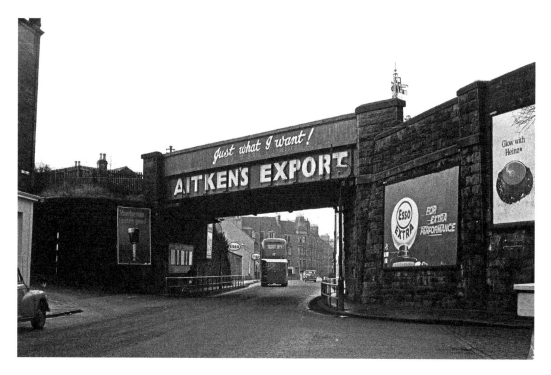

Railway Bridge

The railway bridge marked the point where Lochee High Street becomes Logie Street. Some also maintain that the railway bridge marks the boundary of Lochee itself but, as the following few pages will show, this book takes a wider view.

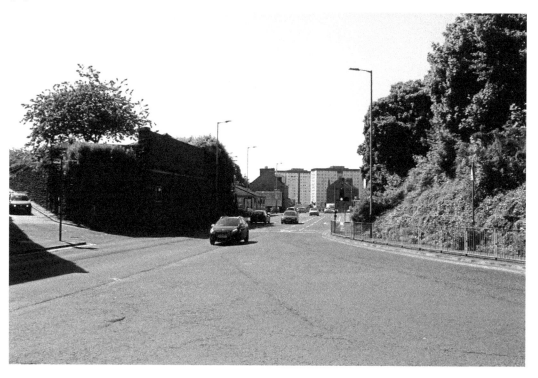

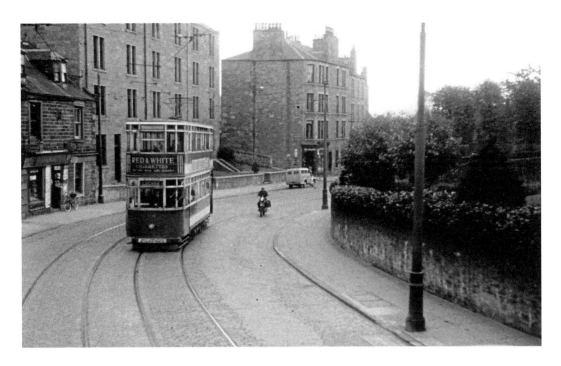

Logie Street

While the shape of the road remains unchanged, not a stone remains standing from this 1950s view of Logie Street, potentially making it difficult to relate to the modern photograph. There are a couple of points of reference. On the left-hand side, the section of Gordon Street that runs down to Logie Street has been replaced by a footpath, while on the right, a GPO inspection cover has managed to survive even the removal of the pavement of which it formed part.

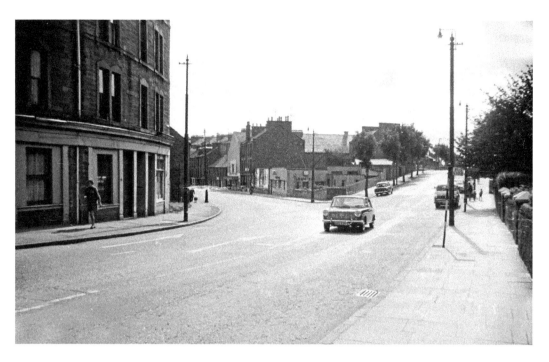

Logie Street at City Road

A little further along the road, the distinctive junction of Logie Street and City Road, as well as the survival of the Logie Bar, makes this view easier to relate to its modern counterpart. In the distance at Logie Steet in the older image is the Astoria Cinema, which, together with the Rialto at Gray's Lane, was one of the area's main venues at the height of the cinema's popularity in Dundee.

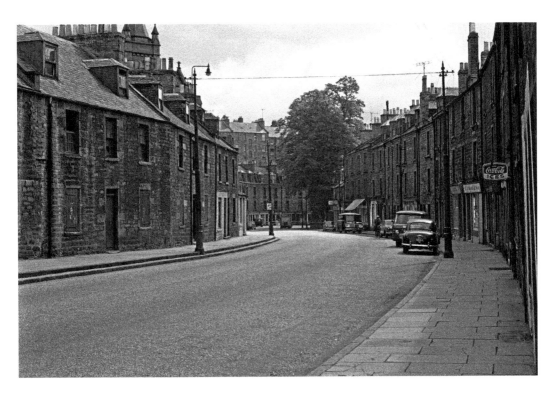

Logie Street at Lochee Road

Until the early 1970s, the area from this part of Logie Street and around the bend of Lochee Road was home to a variety of shops and small businesses, providing what was, in effect, an additional small High Street for the Lochee area. Today, not a single shop remains.

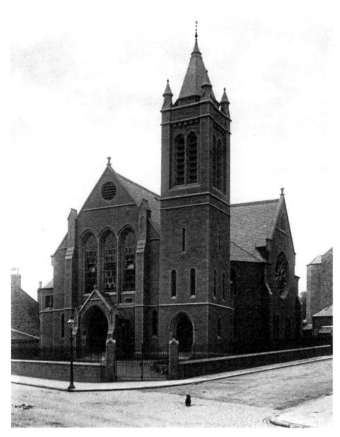

St Columba's Church

St Columba's Church, which stood at the corner of Logie Street and Cobden Street, closed in 1989 and was later demolished. The name is remembered in St Columba's Nursing Home, which took its place. The original church gateposts survive and can be seen in the recent image.

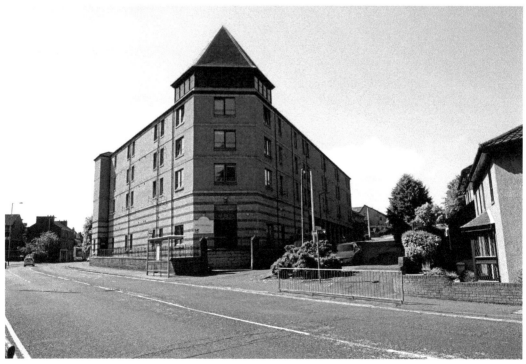

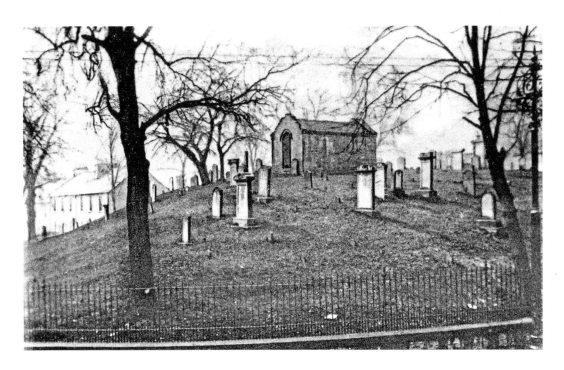

Logie Burial Ground

Logie was once a parish in its own right, dating back to at least the twelfth century. Its church has long since disappeared but the burial ground survives. The building at the top of the mound in the older picture was intended as a family mausoleum by one Major Fyfe, but was actually used as a toolshed. The graveyard was officially closed in 1870, having become overcrowded and a danger to public health, though the last internment was in 1875.

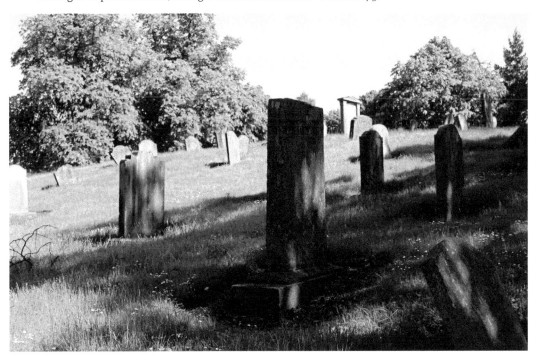

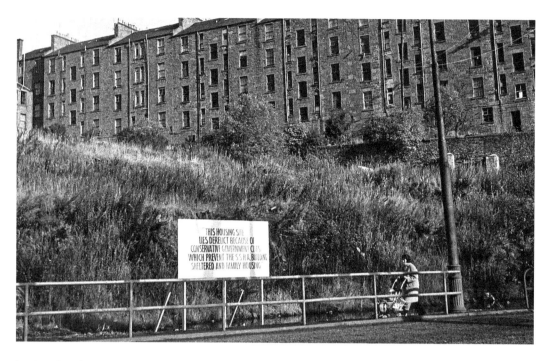

Lochee Road

Even an empty space could be politically controversial in the Dundee of the 1980s. The sign reads:

> This housing site lies derelict because of Conservative government cuts which prevents the SSHA [Scottish Special Housing Association] building sheltered and family housing.

Houses were eventually built on the site, as the modern image shows.

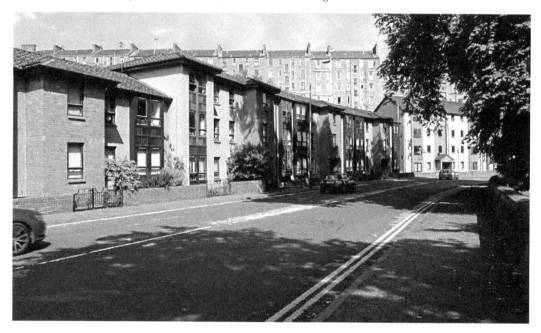

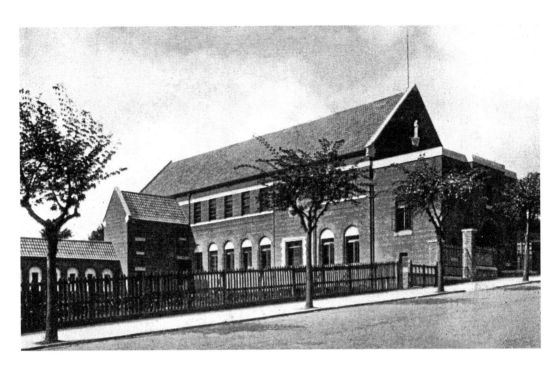

The Friary

The first Franciscan friary in Dundee was established in 1284. After the Reformation, part of its grounds were given to the town by Mary, Queen of Scots, as a burial ground, which is known today as the Howff. It was 1933 before the Franciscan Order returned to Dundee. The archive image here shows the temporary church, which later became the church hall. The Franciscans left Dundee in 1988 but the building remains a place of worship today as City Church.

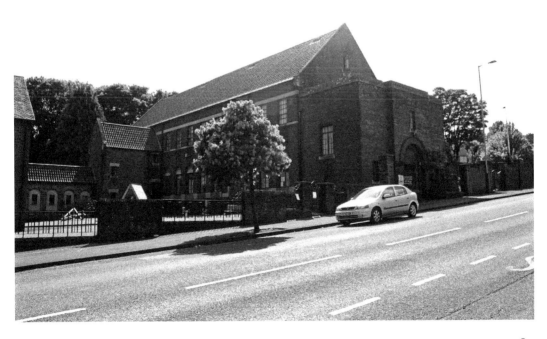

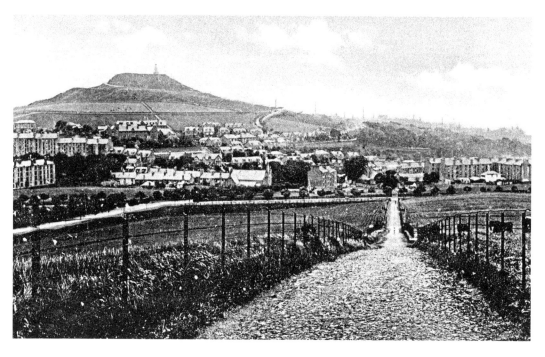

The Coo Road

The old track from Balgay Hill to the Estate of Logie was known as the Coo Road for reasons that are obvious from the older photograph. When part of the track was built on, it was named Greenbank Rise but was later renamed Saggar Street, in recognition of the outstanding public service of the Saggar family in Dundee and, in particular, Jainti Dass Saggar, the popular and respected doctor who was elected Scotland's first Asian councillor in 1936.

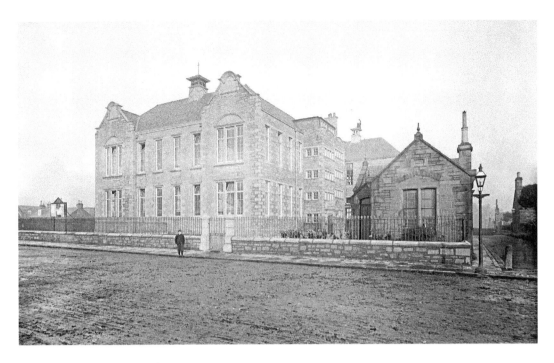

Ancrum Road School

Ancrum Road takes its name from Sir William Scott, 6th Baronet of Ancrum, whose son Harry Scott owned the Balgay Estate upon which it was built. When it opened in August 1875, Ancrum Road School consisted of a single-storey building. Between 1905 and 1906, the school was extended and the older image shows it shortly after that date. By the time of the modern photograph, the janitor's house on the right of the picture had also gained another floor.

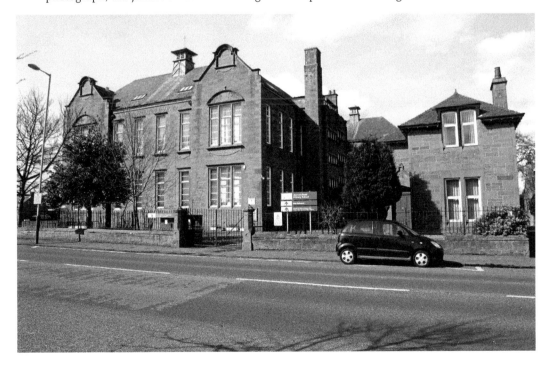

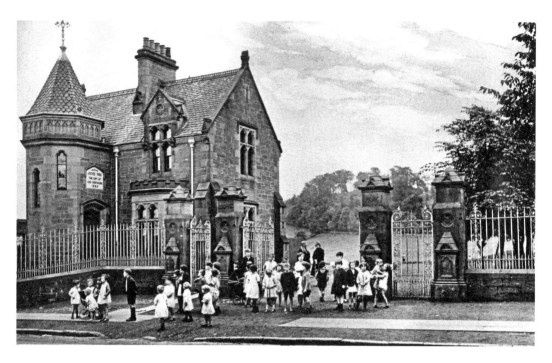

Lochee Park Entrance

As the plaque on the lodge house states, Lochee Park was donated to the local community by the Cox Brothers in 1890. As with Dundee's other parks, the ornate gates and railings shown in the earlier picture would have been removed during the Second World War.

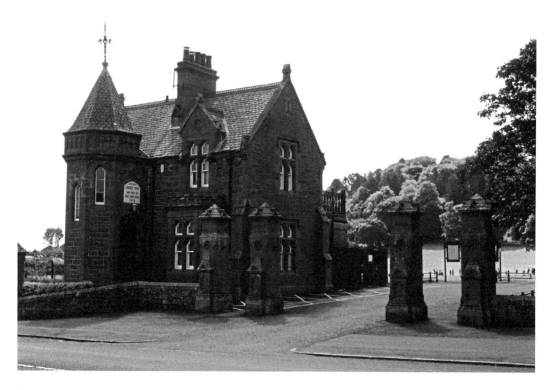

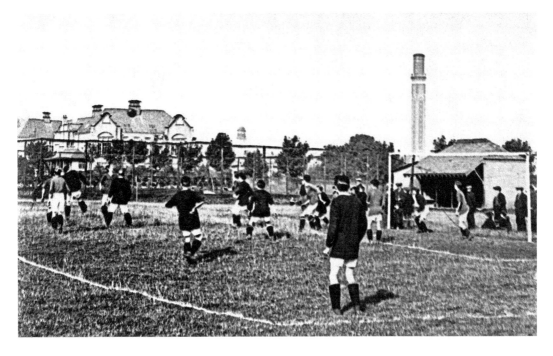

Lochee Park

A 1912 guidebook describes the activities that took place in Lochee Park: 'Football is played in winter and cricket in the summer, also golf in the early morning all year round.' As well as six cricket pitches, the park also boasted a bowling green. Today, cricket is not so common and golf is no longer allowed, but the bowling green survives, and though no match was taking place when the recent image was captured, football's popularity remains undiminished.

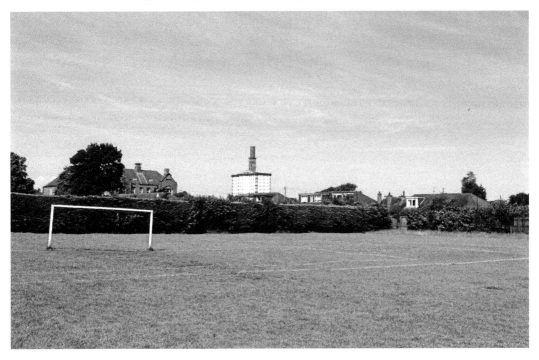

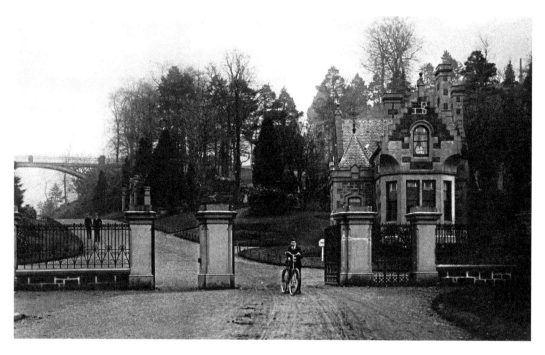

Balgay Hill Park

Balgay Hill Park was officially opened on 20 September 1871 by the Earl of Dalhousie after the local corporation acquired it from the Scott family who owned the Balgay Estate. The entrance shown here has, over the years, lost both its Gothic-style lodge house and decorative ironwork, but, in 2016, it temporarily gained the presence of one of Dundee's most famous characters as part of the Oor Wullie Bucket Trail – a highly successful public art and charity event.

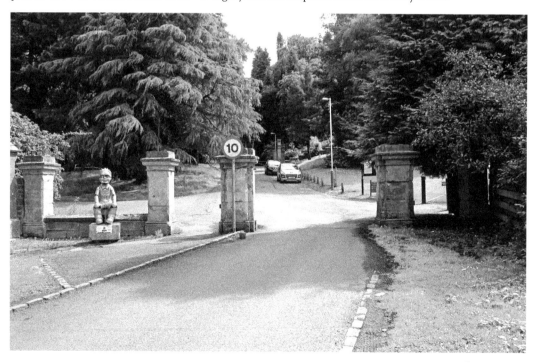

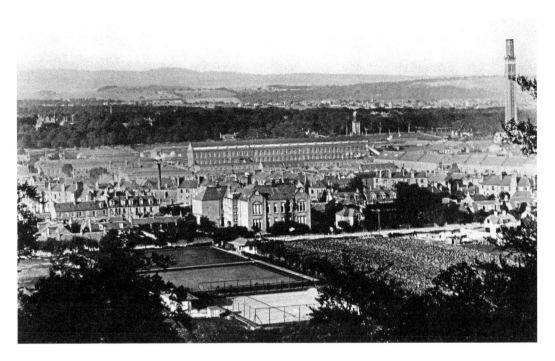

View from Balgay Hill

This view from Balgay Hill looks over Lochee Park Bowling Greens to Ancrum Road School and Camperdown Works. Beyond this, among the trees in the distance in the older photo, are the Cox family mansions: Clement Park, Foggyley and Beechwood. Of these, only Clement Park still exists, though it is now converted to flats (*see* page 4). All three are commemorated in the names of modern housing schemes.

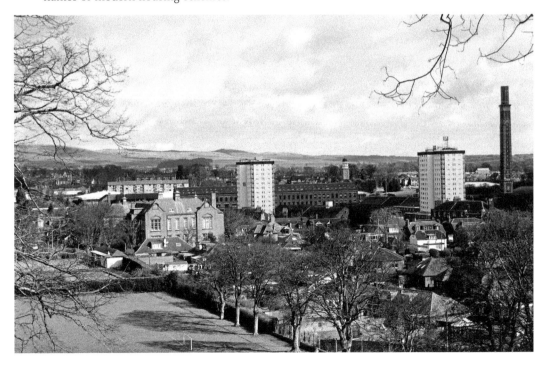

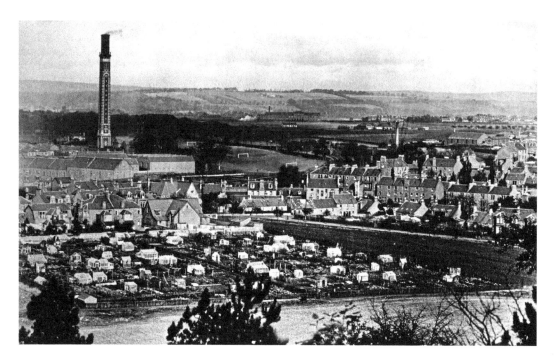

View from Balgay Hill

Cox's Stack provides a good point of reference for comparing these two photographs, presiding over the increasingly built-up nature of the area. The allotments visible in the foreground in the older photograph have been replaced by housing and the green fields in the Harefield Road area to the right of the stack have all been built on.

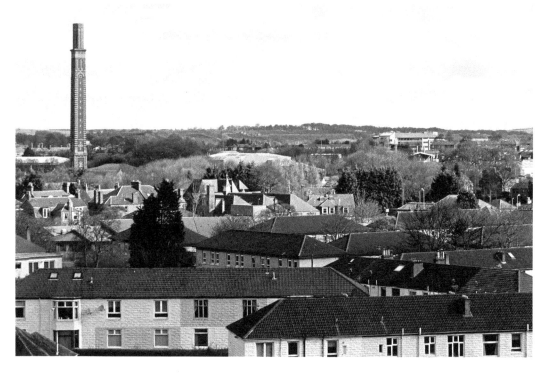